MATHEW BRADY

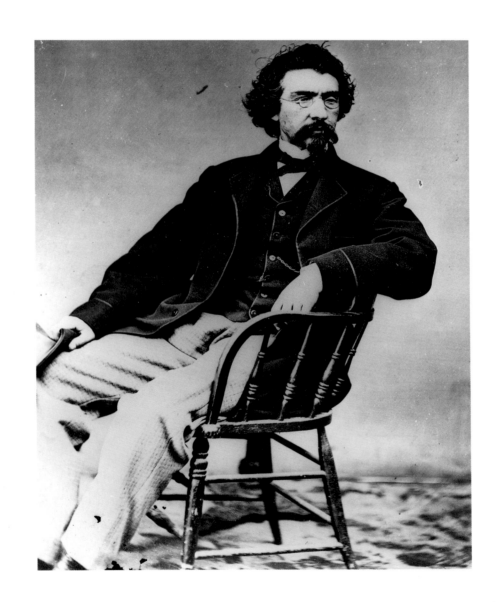

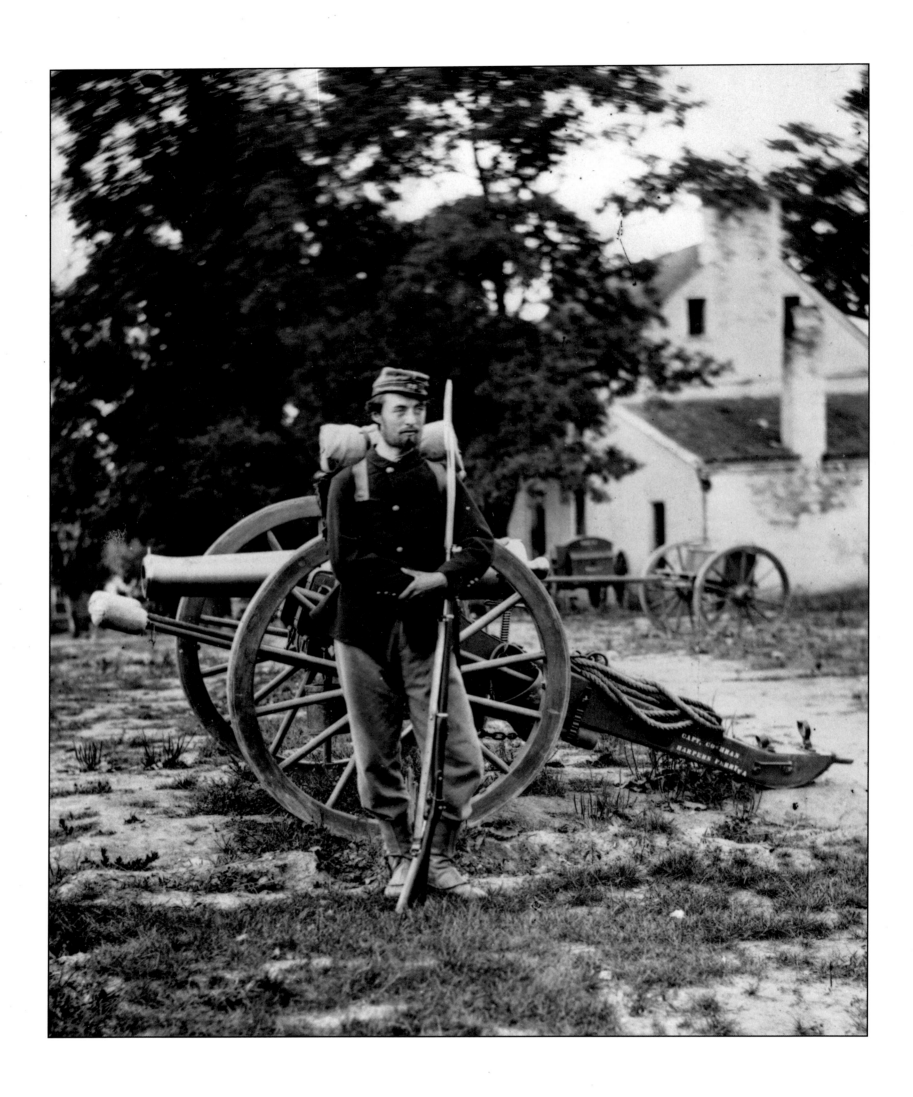

Mathew Brady

Barry Pritzker

JG PRESS

Page 1: Mathew Brady, Washington, D.C., 1861.

Page 2: D.W.C. Arnold, a private in the Union Army, near Harper's Ferry, Virginia, in 1861.

Pages 4-5: Fort Totten, near Rock Creek Church, Washington, D.C., was one of sixty-eight enclosed forts and batteries that encircled Washington, D.C.

Reprinted 2005 by
World Publications Group, Inc.
455 Somerset Avenue
North Dighton, MA 02764
www.wrldpub.net

ISBN 1-57215-342-3
Printed and bound in China by SNP Leefung Printers.

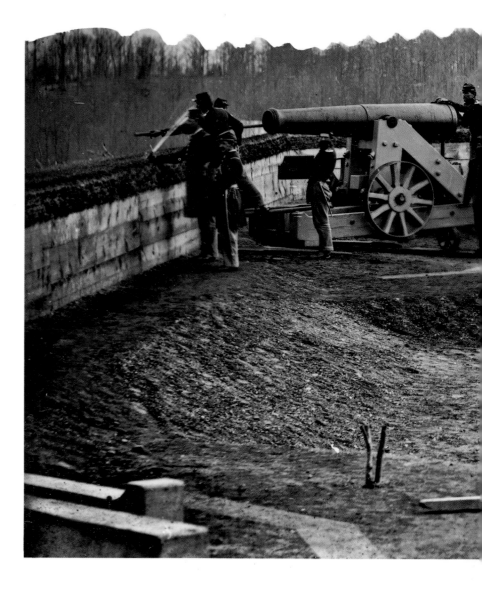

Contents

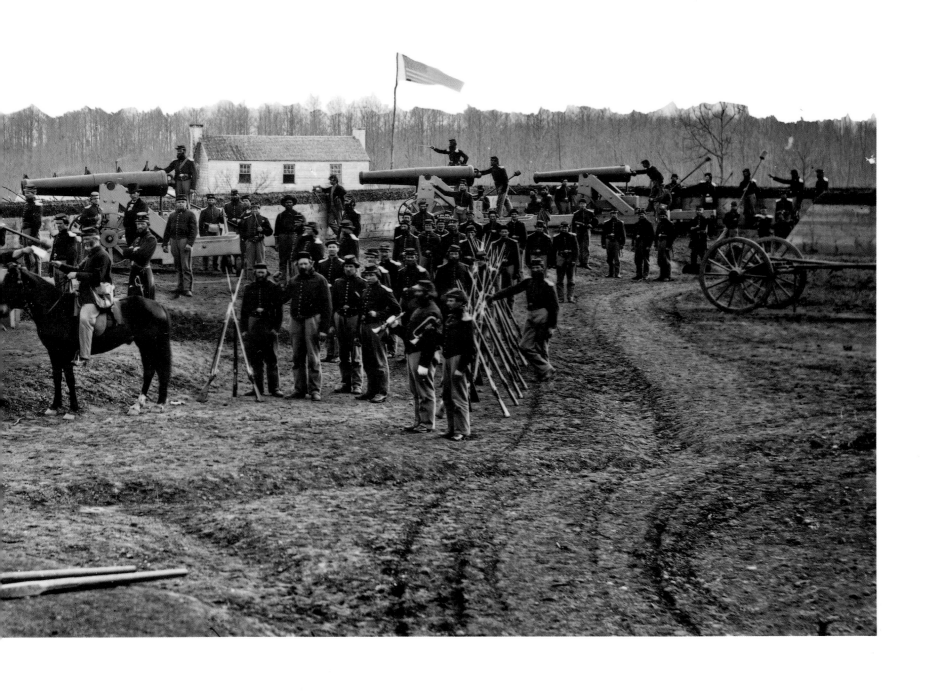

INTRODUCTION

"Brady and the Cooper Union speech made me president!" said Abraham Lincoln. He was referring to a speech he had made at the Cooper Union in New York City on February 27, 1860. A crowd of 1500 people had gathered in front of the free arts and sciences school to hear the Illinois lawyer and presidential contender give a speech on the question of slavery. His eloquence and the strength of his conviction won him a large and enthusiastic following not only among the crowd that day, but, as the text of the speech reached a wider audience, throughout the country as well.

Lincoln also referred in that quotation to Mathew B. Brady, the celebrated photographer, at whose studio he had sat just hours before the speech (this was to be the first of thirteen Lincoln sittings for Brady). At more than six feet four inches tall, Lincoln was not an easy man to photograph. Brady compensated somewhat for his subject's gangliness by hiking up his collar; this "trick" flattered Lincoln by giving the impression that his neck was not so long. When Lincoln's Cooper Union speech hit the papers, pictures of him were in great demand. Brady's photos of Lincoln, depicting the future president as a man of character and poise, were published in *Harper's Weekly* (as woodcuts), in Frank Leslie's *Weekly*, and by Currier & Ives, and were widely circulated during the presidential campaign on banners, buttons and cards.

Left: An oil painting of Mathew Brady by Richard Francis Nagle.

Opposite top: Brady's famous photograph of Abraham Lincoln taken hours before Lincoln delivered his eloquent Cooper Union speech in February 1860.

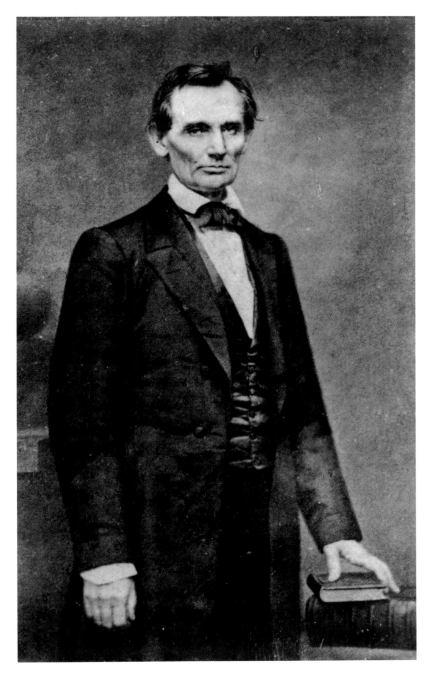

Brady had no way of knowing, of course, how successful Lincoln's speech would be, or how important a historical figure Lincoln would become. (His personal choice for president in 1860 appears to have been Democrat Stephen A. Douglas.) Yet his ability to deliver when the public suddenly wanted pictures of the president-to-be was by no means a complete coincidence. Using what might be considered a particularly American blend of hard work, skill, creativity, showmanship, and hucksterism, Brady built a brilliant career in the mid-nineteenth century as the nation's most famous portrait photographer. Though his own character, including his obsession with photographing the Civil War (a fixation as ruinous to Brady as it was beneficial to historians and posterity) ultimately betrayed him, Brady, perhaps more than any other nineteenth-century photographer, popularized and defined the possibilities of the new medium.

Details of his antecedents and childhood remain sketchy. Mathew B. Brady (he added the "B" as an adult; it stood for nothing) was born in 1823, near Saratoga Springs, New York, a region at the time not far removed from its legacy of rich interaction between Indians, French, British, Americans, and

Canadians. His parents had immigrated from County Cork, Ireland. Brady's father was probably a farmer; even less is known about his mother. He had two older siblings.

At the age of sixteen, Brady left home and journeyed to the city of Saratoga where he became acquainted with William Page, a skilled portrait painter. A friendship bloomed and Page agreed to accept Brady as a student. In 1839, both men traveled to Albany and then to New York City, where Brady continued his painting studies with Page as well as with Page's friend and former teacher, the renowned Samuel F. B. Morse. At this juncture in his life Brady doubtless intended to follow in his mentor's footsteps as a portrait painter. Across the ocean, however, events were taking place in the world of photography that were to change his plans.

As early as ancient times people knew one of photography's basic principles, namely, that light coming through a small aperture casts, on a surface opposite the opening, an inverted image of the scene before the aperture, an image visible in a darkened room. Eleventh-century Arabian scientists used an instrument modeled on this principle for observing the heavens, and during the Renaissance, artists called upon a device known as a *camera obscura*, or "dark chamber," to help them solve problems of perspective. By then a glass lens had replaced the pinhole and the camera had shrunk from the size of a room to something more portable. Correct focus could be achieved by moving a piece of paper inside the camera backward and forward. Mirrors reflected that image onto another piece of paper outside of the camera, which a skilled artist could then trace with a pencil, thereby "capturing" the image in true perspective.

The ancients also observed that light has more properties than its ability to form images. It can also change the nature of

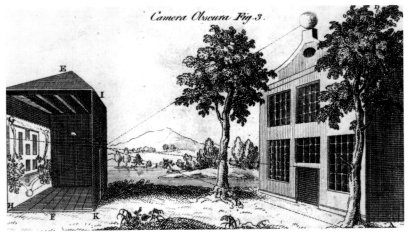

Above: An eighteenth-century engraving of a *camera obscura*. Note the inverted image of the house on the wall opposite the opening.

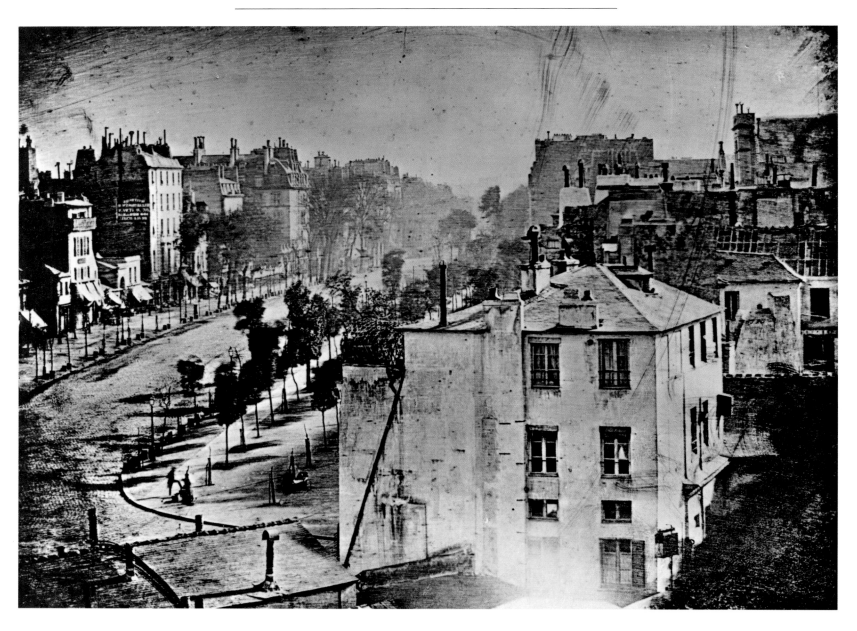

certain substances. Experiments in the early eighteenth century confirmed that some salt compounds of silver manifest a particular light sensitivity. During the course of that century, a growing middle class within such industrializing countries as England, France, and the United States provided a market for such status symbols as affordable portraits. This demand led to an all-out quest to discover, using the technology of the *camera obscura* and elements of photochemistry, a way to capture images directly inside of a camera, by the agency of light rather than that of human artistic reproduction.

The first attempts were only partially successful. Working in the 1820s and 1830s, inventors such as the English scientist William Henry Fox Talbot produced "photogenic drawings" by placing paper coated with nitrate of silver inside of a camera and exposing it to the sun. They had difficulty, however, in producing high quality pictures and in making their images permanent. In Chalon-sur-Saône, France, Joseph Nicéphore Niépce achieved success by using a highly polished pewter plate coated with an asphalt. He placed the plate into his camera and aimed it out of his studio window. For approximately eight hours he exposed his "film" to the sun. After removing the asphalt which was not burned by the sun's light, he was left with a permanent, "fixed" image of the rooftops and chimneys of his neighborhood.

While Niépce experimented with light and asphalt, a Parisian artist named Louis Jacques Mandé Daguerre was trying to make his theatrical set designs even more realistic by copying from nature with the help of a camera obscura. He too began to experiment with the camera. In 1827 Daguerre met Niépce, and two years later, each recognizing the particular talents of the other, they formed a partnership. Niépce died four years later; Daguerre carried on his experiments alone. In early 1839 he heralded the age of photography by announcing his invention of the "Daguerreotype," a silver-coated copper plate that, when exposed in a camera to sunlight, could record and maintain a sharp, accurate mirror image of a subject in as little as half an hour. (Though Talbot's photographs yielded far less satisfactory results than did the daguerreotype, he was somewhat ahead of his time: photographs made on paper, of course, eventually triumphed over those made on plates.) For the price of a lifelong annuity from the French government, Daguerre revealed his process to an astonished world and then retired to a life of relative obscurity.

Samuel F. B. Morse met Daguerre in Paris in 1839 and returned home very enthusiastic about the new photographic process. He immediately had a camera made and began his own attempts at daguerreotypy. Despite the fact that a subject was forced to sit still for the better part of half an hour, the new

Opposite: A rare daguerreotype made by its inventor, Louis Jacques Daguerre, of Boulevard du Temple, Paris, in 1839.

Right: Brady's mentor, the renowned inventor and artist Samuel F.B. Morse, in 1866.

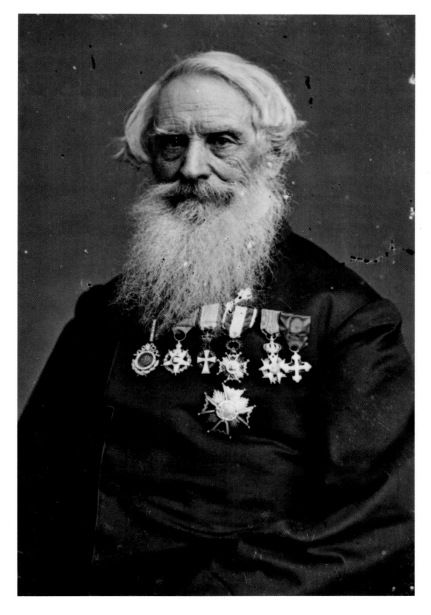

Below: An advertisement for the type of studio equipment used by Brady.

acquainted, and studied art on the side. When Page introduced Brady to Morse, in the fall of 1839, Brady quickly became intrigued by the possibilities of photography. He worked many long hours at Stewart's store to afford the fifty dollar fee Morse charged his students. He may also have moonlighted as a jeweler's helper when he was not working at Stewart's or studying with Morse and his group of artists.

By the end of 1840, daguerreotypes had become a bona fide American craze. Three developments facilitated the spread of daguerreotypy. The first two also reduced exposure time to less than one minute: an improved lens made images sixteen times more brilliant than that used by Daguerre; the light sensitivity of the plate was increased by coating it with "accelerator" solutions; and the tones of the daguerreotype were softened and enriched by gilding (an additional benefit of this process was that it rendered the plate more durable).

With these innovations, daguerreotypy became much more practical, and portrait galleries opened in a number of cities across the country. In 1844, Brady, bright, ambitious and quick to make friends, opened his own gallery in New York City. He had learned all that Morse could teach him. In fact, exhaustive study combined with his skill in portraiture and his willingness to experiment with every discovery and improvement – hand-tinted ivory plaques to produce color daguerreotypes, colored

technique was soon applied to portraiture. Morse, well known as an inventor, artist, and professor at New York University, became the center of a group of New York artists interested in photography. He built a studio and began to offer classes. Among his first students was Mathew Brady, the young man to whom he had been teaching painting.

Brady was a man on the move. Since his arrival with William Page in New York, he had worked as a clerk for A. T. Stewart, the department store tycoon with whom Brady had become

glass lenses, and eventually new technologies such as stereography and "wet plate" photography – made Brady one of the finest such artists in the country. For the location of his "Daguerrean Miniature Gallery" Brady chose the corner of Fulton and Broadway, one of the most desirable neighborhoods in the city.

There is some evidence that two men, A. T. Stewart and the showman P. T. Barnum, Brady's neighbor on Broadway, may have helped Brady financially. He equipped his gallery with only the finest instruments. He employed the most skilled assistants. Skylights provided more and better light. Elegant furnishings and his own expensively framed daguerreotype portraits graced a sumptuous reception room. The gallery even included a private entrance for visiting celebrities. In short, Brady succeeded in creating the most attractive and efficient gallery in the city. Though he was only one of ninety-six professional daguerreotypists in New York City at the time, and such men as John Plumbe, Jeremiah Gurney, and Charles Fredericks provided serious competition, Brady set the standard for both photographic quality and gallery style.

Though Brady was by nature a tireless worker and a perfectionist, he rarely took any of his own photographs. He hired operators just as he hired chemists to prepare and develop the plates and, for that matter, as he bought cameras and other equipment. While his eyesight was never good, and worsened markedly during these early years, even when he could see well enough to focus the camera Brady regarded his primary function as that of proprietor, as did most of the better New York daguerreotypists. He supervised the gallery, selected the equipment and the furnishings, hired the help, acquired the clientele and saw to the quality of the finished product – everything from lighting and posing to retouching and framing.

Brady's penchant for using his camera to document history revealed itself in 1845. He conceived the idea of creating a Gallery of Illustrious Americans, a photographic record of those people he considered to be "the most eminent citizens of the republic." Within a few years he had pictures of Henry Clay, Daniel Webster, Andrew Jackson, John C. Calhoun, John J. Audubon, James Fenimore Cooper, and a host of other luminaries. When the book was published in 1850, with prints of Brady's photographs by lithographer Francis D'Avignon, it also included such equally famous people as Dolley Madison, Chief Justice Roger Taney, Commodore Matthew Perry and a number of Presidents of the United States, including President Polk, the first incumbent President to have his picture taken.

In 1846 the Mexican War broke out, but Brady evidently gave little thought to photographing events south of the border. He was living in New York's fashionable Astor Hotel and engaged in building a thriving business. By the early 1850s he no longer had to search for clients. As one of the best-known photographers in the world, he could choose from among those who flocked to him, many of whom were, as he desired, the most notable people of the day. Widely read publications, such as *Harper's* and Frank Leslie's *Weekly*, featured illustrations almost exclusively after photographs by Brady. The credit line "Photo by Brady" had become a mark of guaranteed quality and unequalled prestige, a symbol of the sort of American-style success embodied by the photographer himself.

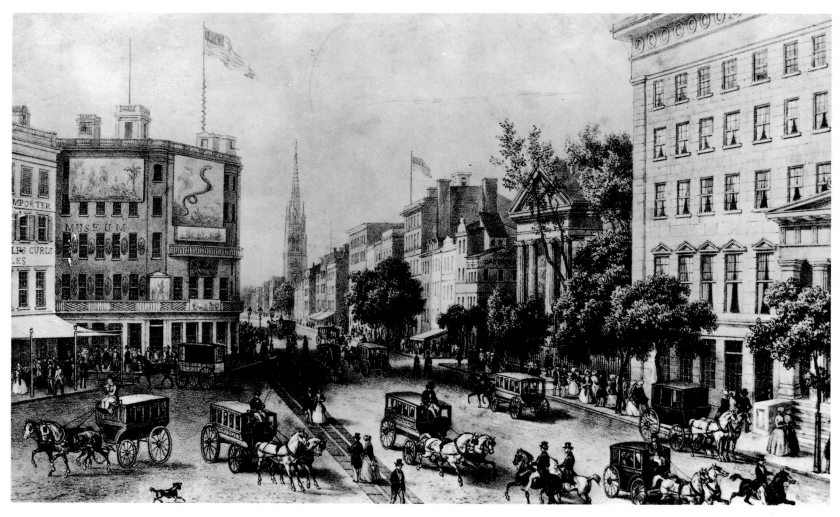

Opposite: A lithograph of Broadway in 1850. Brady's studio is on the right side of the street, opposite Barnum's Museum.

Right: Brady's daguerreotype of Commodore Matthew C. Perry, which was included in *The Gallery of Illustrious Americans*.

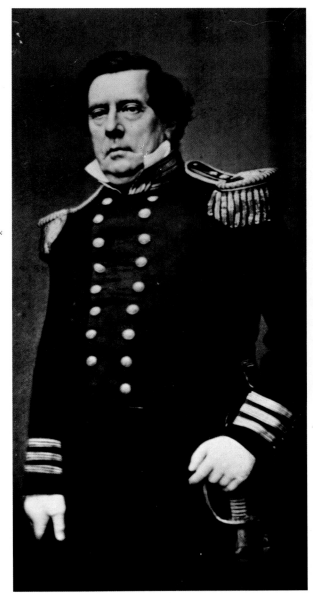

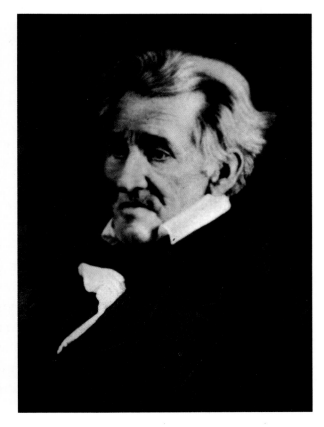

Far right: President Andrew Jackson, photographed in 1845, was included in Brady's *Gallery* though it was probably taken by his competitor Edward Anthony.

Below: The master of self-promotion, Brady used this advertisement citing the Prize Medal he won at the World's Fair in London in 1851.

Like his friend Barnum, who offered "novelties for the study and enlightenment of all," Brady's own self-promotion paid off handsomely.

Brady fell in love and married during a brief stint in the nation's capital, where he tried unsuccessfully to open a branch gallery in 1849. Her name was Juliet Handy, though everyone called her Julia. They courted amid the antebellum opulence of a Maryland plantation. The Bradys never had children of their own, but lavished their attention on Julia's nephew, Levin Handy.

The 1850s were busy years for Brady, and good ones. *The Gallery of Illustrious Americans* was published in 1850. It sold very well in Europe, though poorly in his own country. In 1851, the Bradys traveled to Europe for a well-deserved vacation. Although he did not realize his dream of meeting Daguerre (the artist died on the day Brady sailed), he did enter the photography competition at the International Exhibition at the Crystal Palace in London, one of the first World's Fairs. Competing against the best photographers in the world, Brady won a gold medal for "general excellence." Critics praised his photos for their "uniformity of tone, sharpness and boldness," declaring their quality "unsurpassed." Throughout Europe, royalty and other celebrities petitioned for a sitting, and everywhere Brady found enthusiastic admirers.

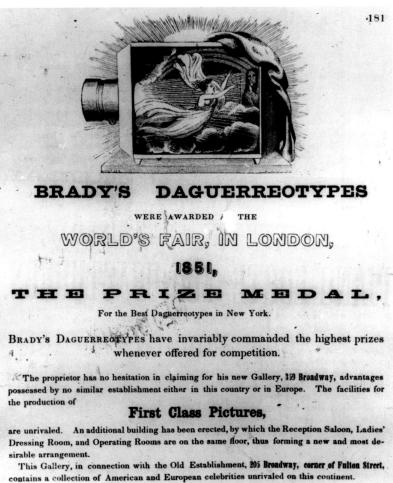

·181

BRADY'S DAGUERREOTYPES

WERE AWARDED / THE

WORLD'S FAIR, IN LONDON,

1851,

THE PRIZE MEDAL,

For the Best Daguerreotypes in New York.

BRADY'S DAGUERREOTYPES have invariably commanded the highest prizes whenever offered for competition.

The proprietor has no hesitation in claiming for his new Gallery, 359 Broadway, advantages possessed by no similar establishment either in this country or in Europe. The facilities for the production of

First Class Pictures,

are unrivaled. An additional building has been erected, by which the Reception Saloon, Ladies' Dressing Room, and Operating Rooms are on the same floor, thus forming a new and most desirable arrangement.

This Gallery, in connection with the Old Establishment, 205 Broadway, corner of Fulton Street, contains a collection of American and European celebrities unrivaled on this continent.

In London, Brady may have met his future partner, Scottish photographer and chemist Alexander Gardner. Gardner was an expert in a revolutionary photographic innovation developed in 1851 by Frederick Scott Archer. Known as the "wet plate process," it enabled a photographer to make a negative image adhere to a glass plate through the use of collodion, a sticky liquid which could be treated to achieve light sensitivity. When developed, "fixed" and dried, the plate could provide an unlimited number of positive copies, which could in turn be enlarged upon demand. Archer's process, resulting in crude (at first) but cheap paper photos, signaled the beginning of the end of the sharp but unique copper daguerreotype.

Brady returned to New York in May 1852 and immediately made plans to open another gallery in an even more stylish section of town. Located further uptown, at Broadway and 10th Street, the new gallery was the most luxurious in the city when it opened in March of 1853. Three years later, Alexander Gardner arrived in New York City and began work as Brady's general manager, helping to complete the transformation to "wet plate" photography begun by his boss.

portrait photograph which sold for 10 to 25 cents. The *carte de visite* was used as a substitute for a calling card and became the subject of a worldwide fad around 1857 and then again at the start of the Civil War.

Brady's galleries prospered under Gardner's capable management, turning out upwards of 30,000 portraits a year. Having Gardner on board gave Brady the confidence to attempt once again opening a gallery in the nation's capital. His dream became a reality in 1858 when he opened the National Photographic Art Gallery on Pennsylvania Avenue, between Sixth and Seventh streets, N.W. Washington, D.C. at the time was little more than an overgrown country town with a putrid canal running through the center. In classic Brady fashion, however, the new gallery featured a spacious and richly appointed reception room, elegantly framed portraits of well-known Washington society and a private "ladies' entrance." Brady sent Gardner south to run the entire operation, and he managed the gallery quite successfully.

The year 1860 was a watershed in so many ways. For the nation, of course, it marked the end of an era. In a sense, the

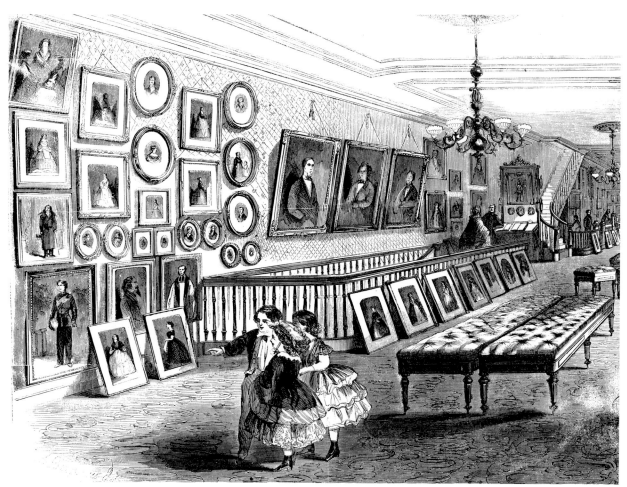

Left: The interior of Brady's gallery at Broadway and 10th Street, reproduced in 1861 for *Frank Leslie's Illustrated Newspaper*.

Opposite: Brady's 1860 photograph of the Prince of Wales, the future King Edward VII of England.

Gardner also brought to the business a fine skill in photographic enlargement. Soon Brady was selling – in addition to the more standard portraits – life-sized, expensive ($50 to $750) "Imperial" enlargements, made even more life-like by his own skilled brushwork and highly paid female retouchers. (Women also did the delicate shading of glass negatives and worked as hairdressers, framers, clothes straighteners, and, very occasionally, as operators.) At the other end of the spectrum was the *carte de visite*, a tiny (2.5″ × 4″) mass-produced

same may be said about Mathew Brady, for his career reached its zenith at about that time. One of his finest moments came in October of that year when Edward, Prince of Wales and heir to the throne of Queen Victoria, arrived in New York. Although competition was fierce among New York's finest photographers to win the royal sitting, it was Brady's studio to which the Prince and his entourage repaired. When Brady ventured to ask the Duke of Newcastle the reason for this honor, the Duke replied, "Are you not the Mr. Brady who earned the prize nine

Right: An example of the very popular *carte de visite*, used as photographic calling cards. These are of Dr. Mary Walker, the first woman awarded the Medal of Honor.

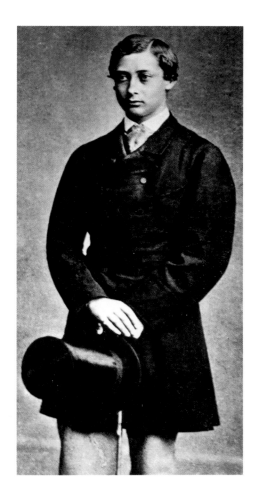

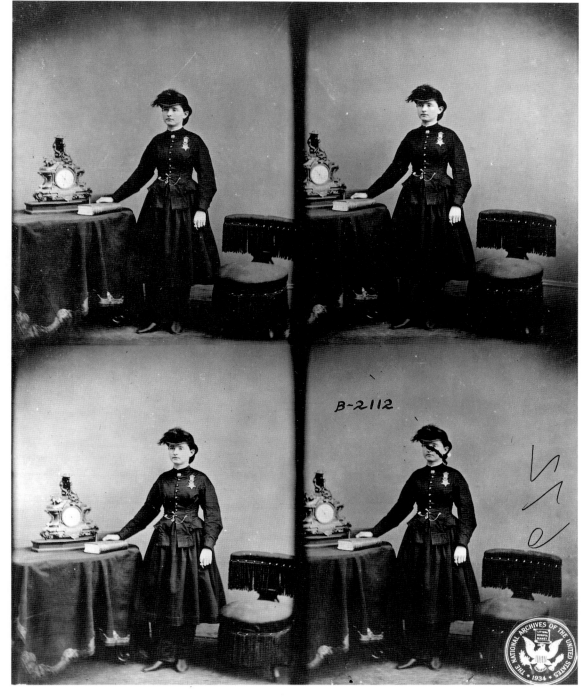

years ago in London? We had your place of business down in our notebooks before we started."

Photographing the Prince of Wales was one of the last diversions Brady was to enjoy. He also took the official photographs of President-elect Lincoln and his family. The United States was changing fast. Social, political and economic forces, symbolized by the emotional and deeply divisive issue of slavery, were quickly driving the country toward civil war. The resulting slaughter had profound consequences both for the country as a whole and for Brady.

Sectional conflict had been building for years, if not decades. The election of Abraham Lincoln in November 1860 as President of the United States was the last straw for the South, a region that felt itself squeezed to the limit by high tariffs and Northern disregard for, as they saw it, their constitutional right to own slaves, as well as hostility toward their way of life. Within weeks after the election, South Carolina declared its secession from the Union. Other southern states followed shortly thereafter, while border states agonized over their loyal-ties. Sentiment in the North ran in favor of preserving the Union at all costs. The following April, when the Confederates seized Fort Sumter, in South Carolina, Union armies prepared to answer the challenge. The deadliest war in United States history had begun.

At first, the extent of the war's impact on Brady was a great increase in business, primarily making *cartes de visite* for thousands of transient soldiers. It was not long, however, before the idea of documenting the war with photographs took hold of him. Although his wife and friends were cool at best to the idea, according to Brady mythology he conceived of himself as a man of destiny: "Like Euphorion, I felt I had to go, a spirit in my feet said 'go' and I went . . ." Alexander Gardner always claimed that covering the war was his idea. In any event, Brady applied to his old friend, General Winfield Scott, and then to Lincoln himself, for official permission to photograph the war. Perhaps recognizing the potential applications of photography to military intelligence, Lincoln granted it in 1861, on condition that Brady finance the project himself.

Hundreds of photographers, mostly civilians, covered both sides of the Civil War, taking pictures of maps, plans and documents for distribution, as well as bridges, key installations and topography for study. When not busy with their military assignments, they shot war scenes to be sold back home. Yet, while Brady was not the only Civil War photographer, or the best, or even the most important, he certainly was the most famous. He must also be given credit for his courage and initiative in moving a miniature studio into a combat area. The British lawyer Roger Fenton had photographed scenes from the Crimean War in 1855 from a similar traveling darkroom, but the idea of extensive photographic war coverage on a grand scale was unprecedented.

On the other hand, Brady's true project and passion was essentially to collect, not personally execute, as many photographs of the Civil War as possible. By this time he had long since ceased to work the camera. Among the operators he employed during the course of the war, for approximately $35 a week, were Alexander Gardner, George N. Barnard, Guy Foux, Timothy O'Sullivan and a host of other talented men who went on to make distinguished names for themselves in the world of photography after leaving Brady. As usual, a "Brady" photograph was any taken when the proprietor was on the scene – persuading an officer to pose, framing the scene, arranging for batteries to be placed in photogenic locations – or one taken by anyone in his employ, whether Brady was actually present or not. In time, photographs he simply bought or acquired by trade also became part of his collection.

Brady did, however, personally cover several battles that took place fairly close to home. Often he hurried back to Washington after his work in the field to promote his photographs, either through prints exhibited at his galleries or through reproduction in one of the weekly magazines. He was present at the First Battle of Bull Run, for example, and became caught in the rout suffered by Union forces. Cut off from his companions, Brady spent the night alone in the woods, listening to the sounds of the wounded and dying on the nearby battlefield and hoping not to be discovered by the enemy. He reached Washington the next day, worn out and with much of his equipment damaged. Still, the newspapers had nothing but praise for his "pluck" and his "numerous, excellent views" of the war. "His," they declared, "are the reliable records of Bull Run."

Battlefield photography made a large impression on the public, bringing home the reality of war in a way that paintings or newspaper accounts never could. Yet during the Civil War it was no light task. Brady's traveling darkroom, or "What-is-it" wagon, as it came to be known, first had to get to the action, traveling along back country roads, ridged with deep, iron-hard ruts in winter and transformed into semi-swamps in summer. Sharpshooters in the trees were a constant threat.

Inside the wagon were cameras of different sizes, chemical tanks, tripods, and several hundred fragile glass plates, upon which the success of the entire operation depended. When ready for use, the plates, usually 8″ × 10″, were carefully coated with collodion (a delicate operation even in a normal studio), lowered into a solution of nitrate of silver for three to five minutes and then placed in a holder, ready for insertion into

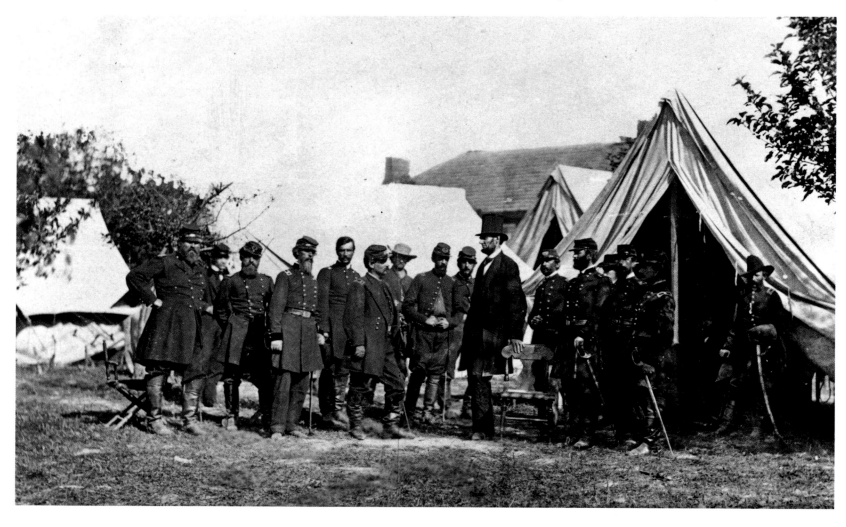

Opposite: Alexander Gardner
started out as Brady's assistant
and became a noted
photographer in his own right.
Here is his picture of President
Lincoln meeting with General
McClellan at Antietam. To the
far right, away from the group
of officers, is Captain George
Armstrong Custer.

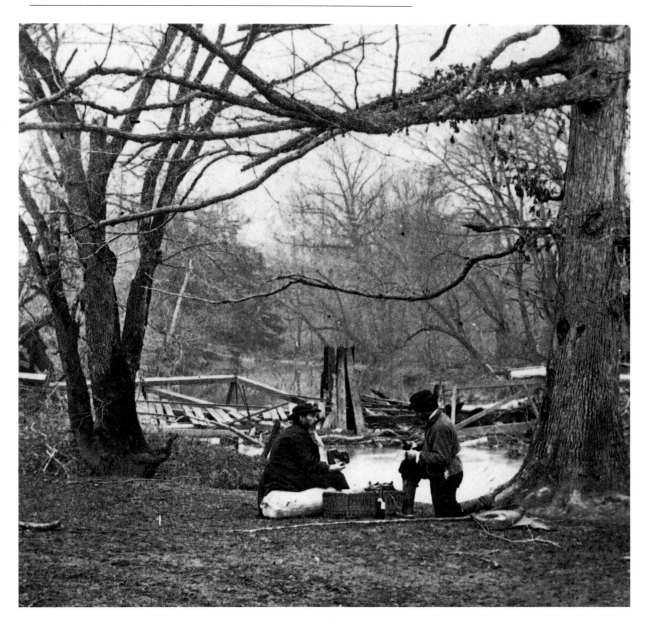

Right: Two photographers
having lunch at Blackburn's
Ford near Bull Run before the
second battle, 1862.

the camera. After exposure, the plates were returned for developing to a darkroom that was stuffy at best and rank from post-battle aromas at worst. The time between coating the plates and developing them did not normally exceed eight or ten minutes. A breath of wind, a bit of light or a sudden jolt could ruin the whole process.

As the war progressed, Brady outfitted a corps of about 20 photographers, maintaining 35 bases of operation, at a total cost, including salaries and equipment, of nearly $100,000, or approximately his entire net worth. By 1862, Gardner, as well as O'Sullivan and Foux, had left Brady, the former having been annoyed for years by Brady's refusal to credit him for his own work. Brady himself spent much of his time in New York, leaving management of the Washington gallery to the dubious talents of James F. Gibson. In the meantime, the Union army was slowly evolving from an almost completely incompetent ragtag band of volunteers to a reasonably disciplined, well-led fighting force. The Emancipation Proclamation, issued on January 1, 1863, increased public support for the war. Union defeats, commonplace early in the war, became fewer.

Toward the end of the war, Brady began to experience serious financial pressures. He had never been very interested in the financial side of his business. For years he had spared no expense in underwriting his special project, an enterprise

which had begun to assume the cast of an obsession. Even before the war's end, he had depleted virtually all of his assets. A further drain on his resources was the expensive lifestyle to which he had become accustomed. He ignored his bills for fancy clothes, food and hotel suites, all the while buying more and more plates and chemicals on credit. The two works that Brady published during the war, his *Album Gallery* and *Incidents of the War*, brought him little relief. In September 1864, in an effort to save the Washington gallery from failure, he accepted its incompetent manager as a partner in exchange for a small amount of cash.

Still, Brady enjoyed fame and reputation. In 1864, the last full year of the war, he made eight wonderful portraits of Lincoln as well as several fine pictures of Ulysses S. Grant. The latter was in Washington to receive the rank of Lieutenant General, only the third man in American history, after George Washington and Winfield Scott, to achieve this honor. At least business in New York was still good.

With Grant in command of the Union forces, and Sherman's successes in the deep South, the outcome of the war was no longer in doubt. The end came on April 9, 1865, with General Lee's surrender to Grant in Appomattox Court House, Virginia. Oddly, perhaps, with so many photographers in the field, not one was on hand to document the surrender. Several

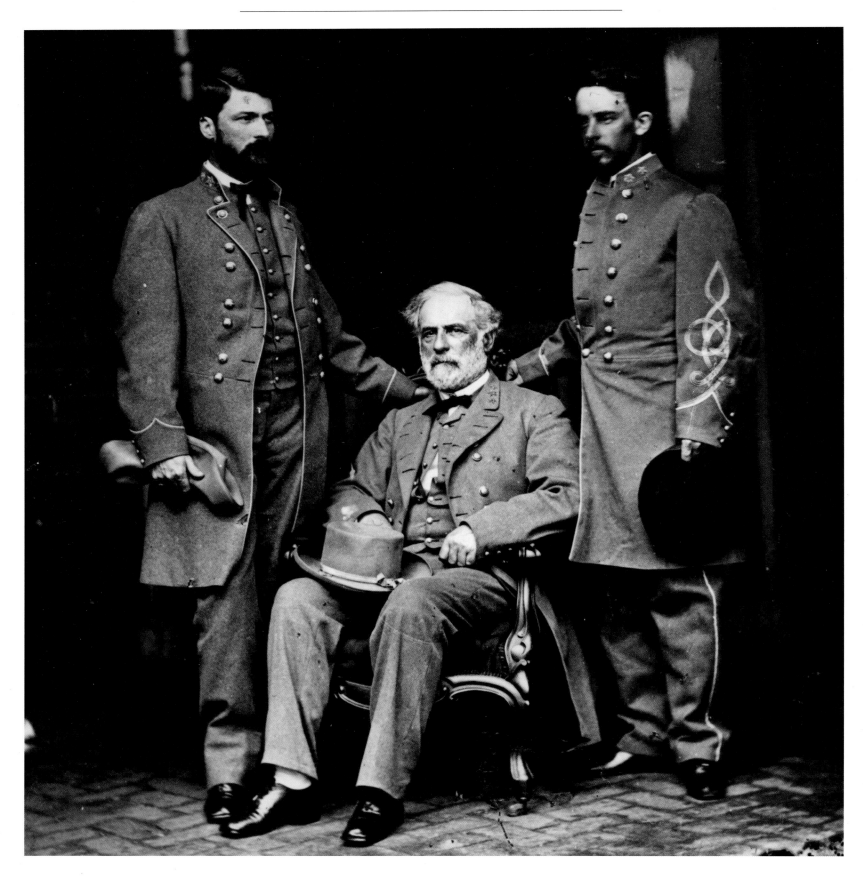

days later, Brady arrived in Richmond and made his way to the home of General Lee. Brady had known Lee since the time of the Mexican War and apparently thought the General would allow his picture to be taken. At first rebuffed, Brady later received permission and made several somber photographs of Lee, wearing the uniform he had worn at Appomattox. Within the week Lincoln was dead, the victim of an assassin's bullet.

Half a million people died and countless others were wounded, maimed, dislocated and destroyed during the Civil War. While people valued photographs of the war at the time, the overwhelming sentiment afterwards was to forget. This left Mathew Brady in a very awkward position. He had staked his

career on the Civil War. When it ended, his good operators had left him, his wife was ill, he was heavily in debt and the war was not a popular subject.

He was a man whom time had passed by. Once fascinated by photography, he no longer kept up with new developments such as fast celluloid roll film, the aluminum foil flash and the gelatin "dry plate" technique, which replaced the wet plate in the 1870s. The latter permitted a plate to be prepared long before and developed long after a photograph was actually made; two of its many consequences were action photography (these plates were far more sensitive, vastly reducing exposure times) and hand-held cameras. Once the most fashionable

Opposite: Brady photographed
General Robert E. Lee at Lee's
house in Richmond shortly
after the surrender. With Lee
are his son George Washington
Custis Lee and Colonel Walter
Taylor.

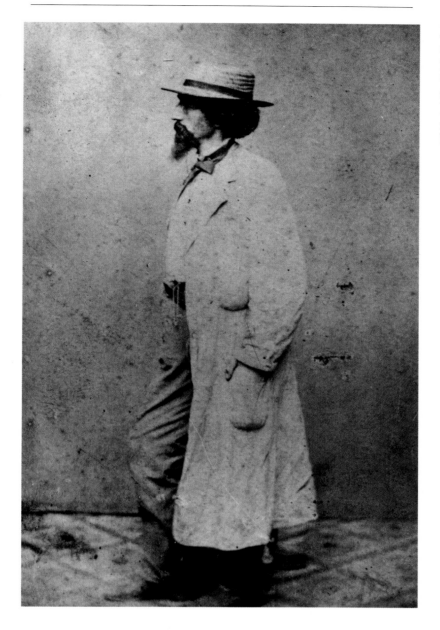

Left: Mathew Brady, America's
most important early
photographer. This picture was
taken immediately after Brady
returned from the first battle of
Bull Run, 1861 – his quest to
record the Civil War had just
begun.

photographer in the country, if not the world, he found that
others (notably, an American named Napoleon Sarony) had
taken his place. His life quickly turned into a struggle just to
keep his head above water.

He did, of course, own an incredible collection of Civil War
plates. He earnestly felt that they belonged in the public trust,
and continually, but fruitlessly, petitioned Congress to pur-
chase his collection. In 1868, Brady went into voluntary bank-
ruptcy to get rid of Gibson. In the early 1870s, his friend
William "Boss" Tweed lost control of New York City. Protec-
tion formerly extended him from court judgments suddenly
ended, and Brady, faced with an avalanche of demands, was
declared bankrupt. Drinking heavily now, and fighting painful
rheumatism, Brady finally succeeded in persuading Congress to
buy a portion of his collection, but, in the bitterest of ironies,
realized no profit from the sale, having lost title to the plates
during the bankruptcy proceedings. Finally, in 1875, Congress
allotted Brady $25,000 for clear title to the negatives.

After paying his debts, however, little cash remained. He
had already lost his New York galleries; soon the Brady
National Photographic Art Gallery folded. In 1887 his beloved
wife Julia died, leaving Brady despondent, lonely and con-
fused. He spent the remainder of his life living in cheap board-
ing houses, working on and off for other photographers,

notably his nephew, Levin Handy, and reminiscing about the
past. A street accident involving a runaway horse crippled him
and ended his photographic career for good. Finally, on
January 16, 1896, Mathew Brady died of a kidney ailment in
New York's Presbyterian Hospital. He was buried, alongside his
wife, in the Congressional Cemetery in Washington, D.C.

Such a sad and gloomy end, however, should not detract
from or obscure the signficance of the man who is widely con-
sidered the most important early American photographer.
Brady would be proud to be remembered as a photographic
pioneer. Present at its birth, he brought to the medium quality
and distinction. Having once been famous for his exquisite pic-
tures, he also inspired countless future photographers. Brady
showed the way to those who would understand and exploit the
power of pictures: his photographs helped to create the public
image of countless people, with potentially profound results, as
Lincoln himself acknowledged in the opening quotation.

Perhaps above all, he regarded himself as a pictorial histor-
ian, one who, despite his talent as a promoter, had a higher pas-
sion than money. As he once put it, commenting on his mis-
sion in life, ". . . from the first, I regarded myself as under
obligation to my country to preserve the faces of its historic
men and [women]." For this dedication, his sense of patriotic
vision, we owe Mathew Brady a great debt.

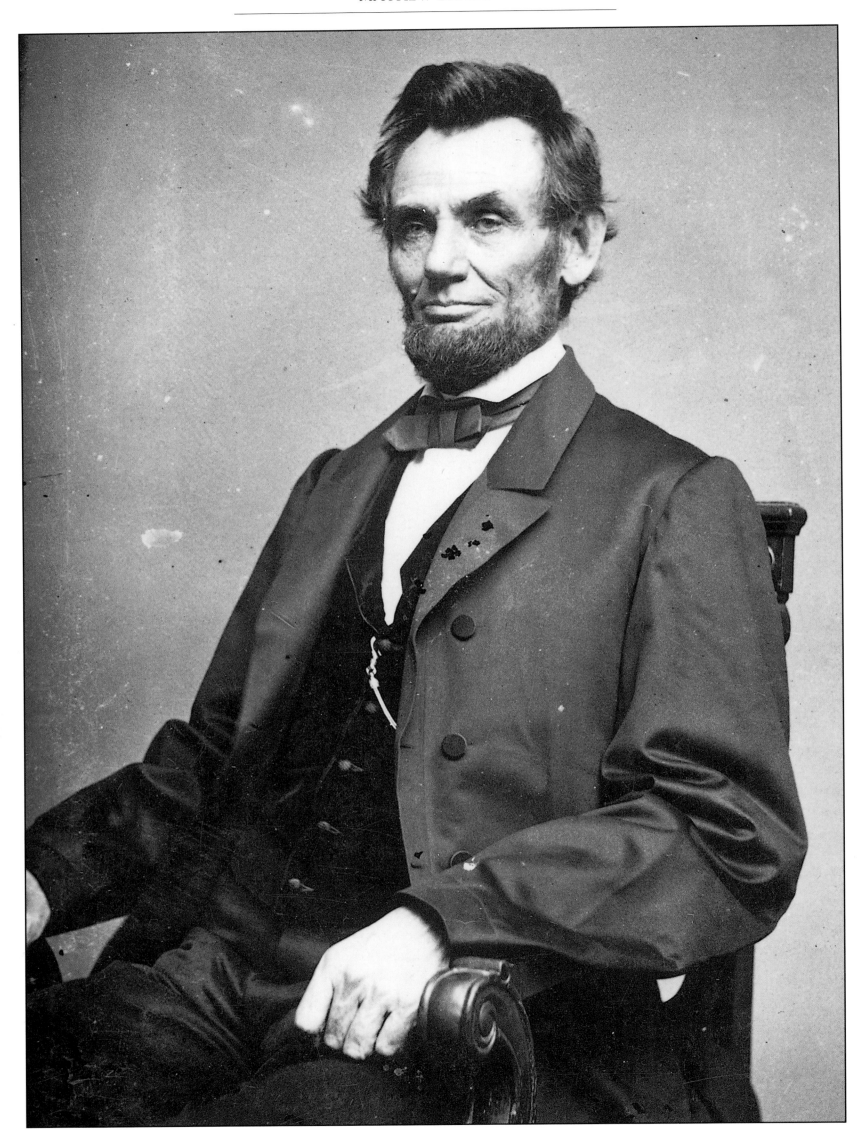

PORTRAITS

Although Mathew Brady is most widely known today for his Civil War photographs, it was his portraits that originally brought him fame and fortune. Almost overnight, he transformed himself from just another art student with an interest in photography to "Brady of Broadway," society's darling and one of the most well-known photographic portrait artists in the world. Brady's meteoric rise was due primarily to two factors, neither of which would have worked without the other: he produced excellent daguerreotypes, and he possessed an equally fine talent for publicity.

Many of the men and women Brady sought as subjects wielded power and influence. They should have been too busy to take the time to have their picture taken, yet that is exactly what they did, helpless before Brady's charm and quiet persuasion. These qualities seldom failed him, but when they did, Brady resorted to recruiting friends of the desired subject to lobby on his behalf. This strategy worked more often than not, for he knew everyone from millionaire merchants to big city bosses to politicians prominent on the national scene.

Webster, Calhoun and Clay, three giants of antebellum U.S. politics, all sat for Brady in 1849. Webster came at the bidding of a mutual friend, sat for three exposures, and left quickly, thrilled to be free from the clutches of the ubiquitous iron clamp, or "immobilizer." Calhoun consented because a child wanted his photograph for her locket. Henry Clay at first refused the invitation, but later consented when friends interceded on Brady's behalf. He insisted, however, that Brady accommodate his busy schedule by making the portrait at City Hall. A police escort rushed Brady across town and through the throngs of spectators. Twice, just when all was ready, Clay's admirers interrupted the session by surging into the room. At length, Clay raised his hand, the crowd fell silent, and the photographer exposed the plate.

By the end of his career, Brady's collection boasted no fewer than twenty Presidents of the United States. Everyone from John Quincy Adams, our sixth president (and son of our second), to William McKinley, our twenty-fifth president, who served until he was assassinated in 1901, sat before Brady's cameras at some point in their lives. (Some students of Brady, however, suspect that the portraits of Adams and Andrew Jackson were not actually taken by Brady or his assistants.) In his later years, Brady's actual role in photographing the presidents was sharply limited, but at the height of his career it was he who knocked at the door of the White House, arranged the background and posed the subject. Most presidents cooperated willingly, knowing that a "Brady" would circulate widely, gaining them, as well as the proprietor, valuable publicity.

Since Brady did not adopt the "wet plate" process until the mid-1850s, he took many of his best portraits as daguerreotypes. This cumbersome process involved first immobilizing the subject with an iron clamp. Then a sheet of silver-plated copper was thoroughly cleaned, polished and exposed in a dark area to iodine vapor for light sensitivity. The subject was given strict orders not to move a muscle, and a piece of glass originally placed inside the camera for focus was carefully removed and replaced by the prepared plate.

After exposure (Brady's precise exposure times are unknown), the plate was removed from the camera, "developed" by treatment with mercury vapor, and then washed in baths of hyposulfite of soda (to "fix" the image) and distilled water. The finished product (generally, for Brady, a "half plate" of $4'' \times 5\frac{1}{2}''$) typically sold for around $2.50, including case.

Not all daguerreotypes fetched this price. By 1860, the number of commercial daguerreotypists had risen to over 3,000 from under 1,000 just ten years before. Competition for business drove the price of inferior daguerreotype portraits to as low as 50 and even 25 cents, prompting Brady to appeal to his customers' vanity by declaring that an "enlightened public" would recognize the difference between "true art" and "real excellence" (his product) and "tastelessness" and "meanness" (that of his rivals).

Despite the excellent quality of Brady's photographs, characterized by a classic simplicity and an artful use of light, his use of the word "art" must be taken somewhat loosely. He certainly believed his merchandise to be of superior quality, but, unlike other first-rate daguerreotypists of his time, the former portrait painter likely saw photography as primarily utilitarian in nature. He believed that true photographic art could only be produced by painting over daguerreotypes, a process at which he excelled.

Left: Abraham Lincoln (1809-1865), lawyer, 16th President of the United States of America, 1864.

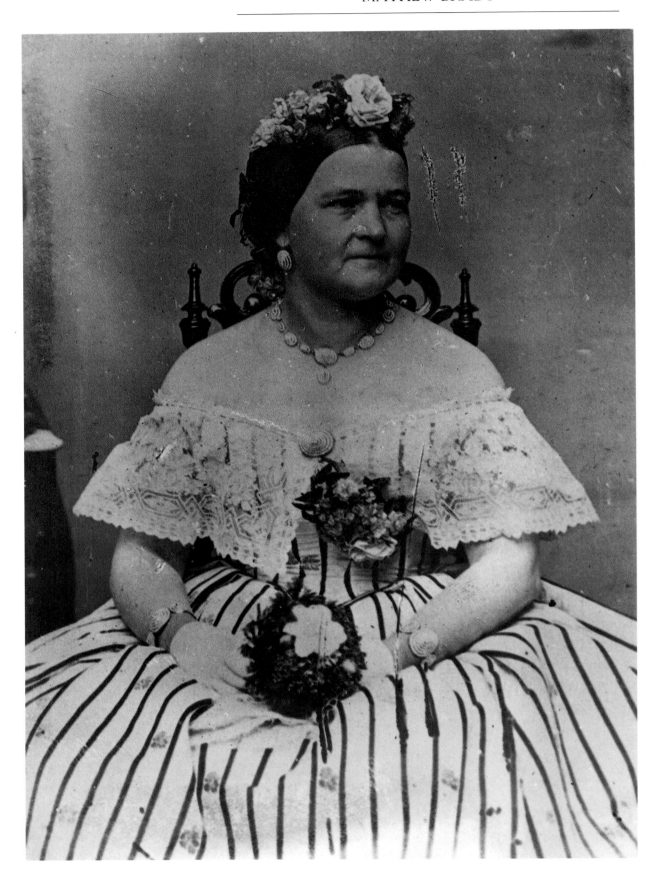

Mary Todd Lincoln (1818-
1882), wife of Abraham
Lincoln, photo taken before
the first inauguration, 1861.

Right: Brigham Young (1801-
1877), Mormon leader and
prophet. Daguerreotype.

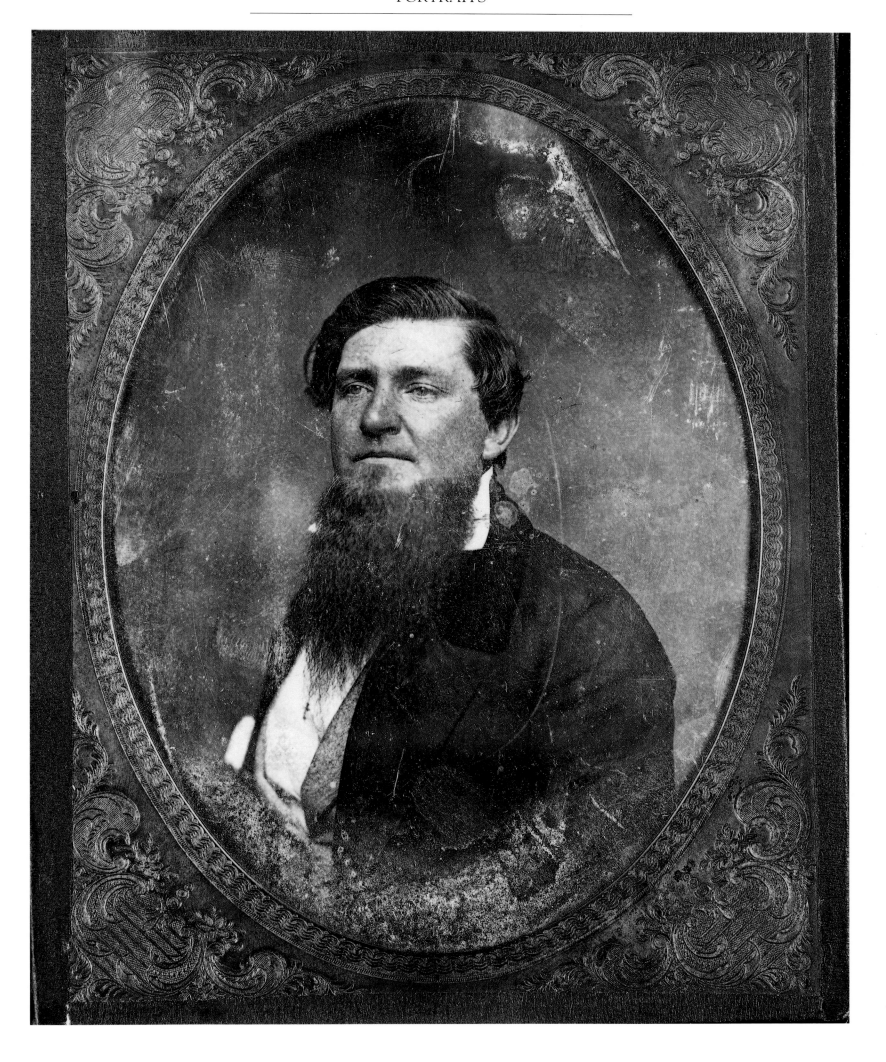

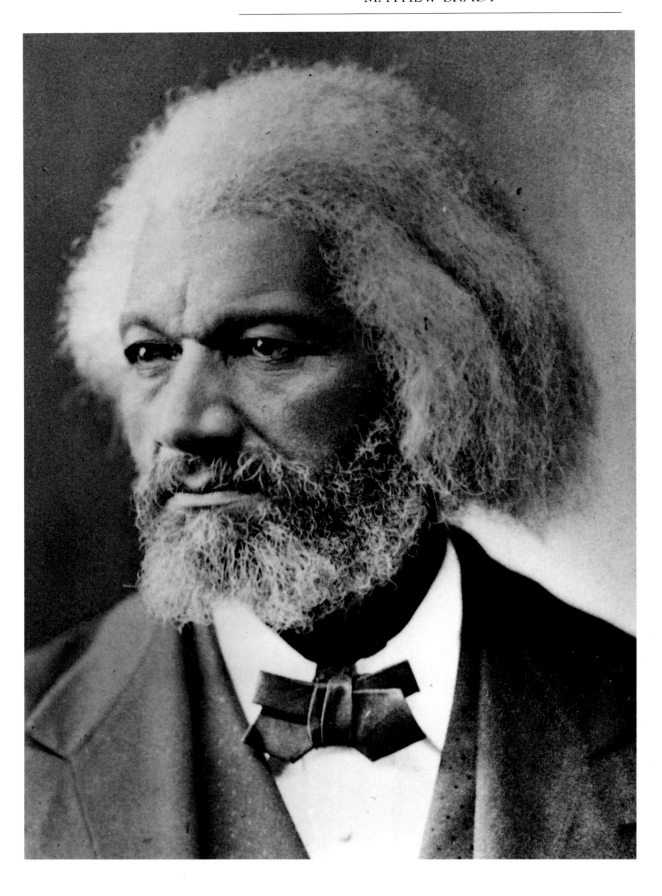

Frederick Douglass (c. 1817-
1895), American abolitionist,
orator, journalist.

Right: John C. Calhoun (1782-
1850), American politician,
lawyer, congressman, secretary
of war, vice president, political
philosopher. Daguerreotype,
c. 1849.

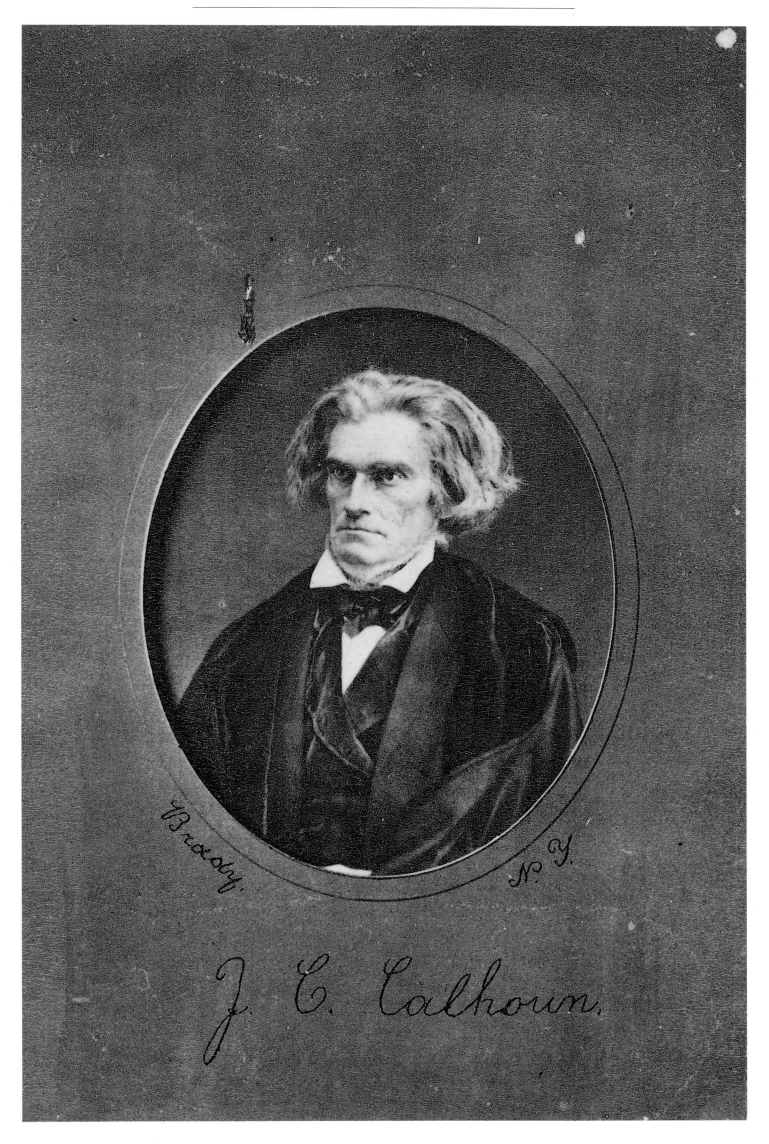

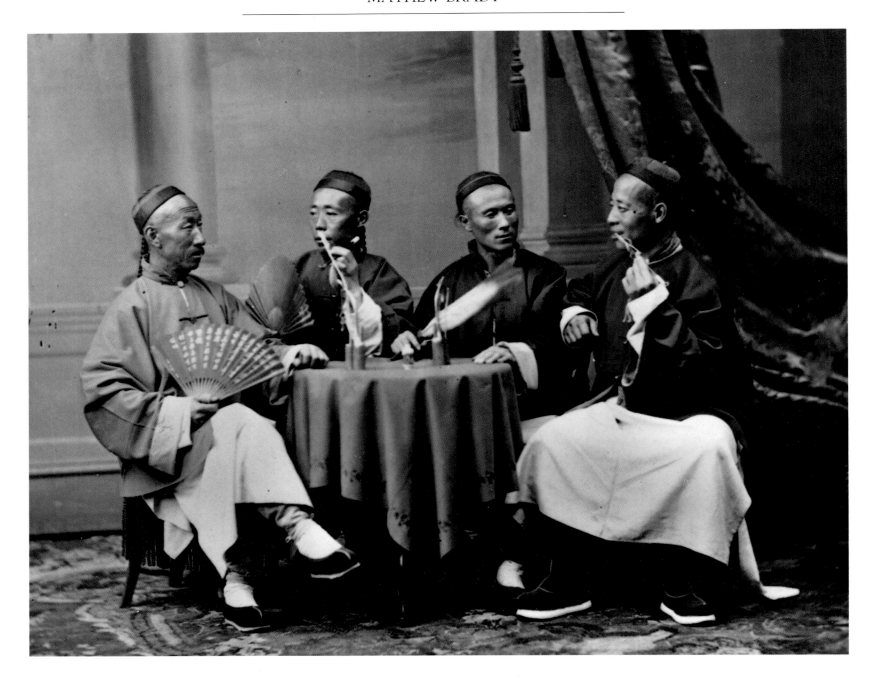

Chang, Hang, Kwang and
Kivae, n.d.

Right: Walt Whitman (1819-
1892), American poet.

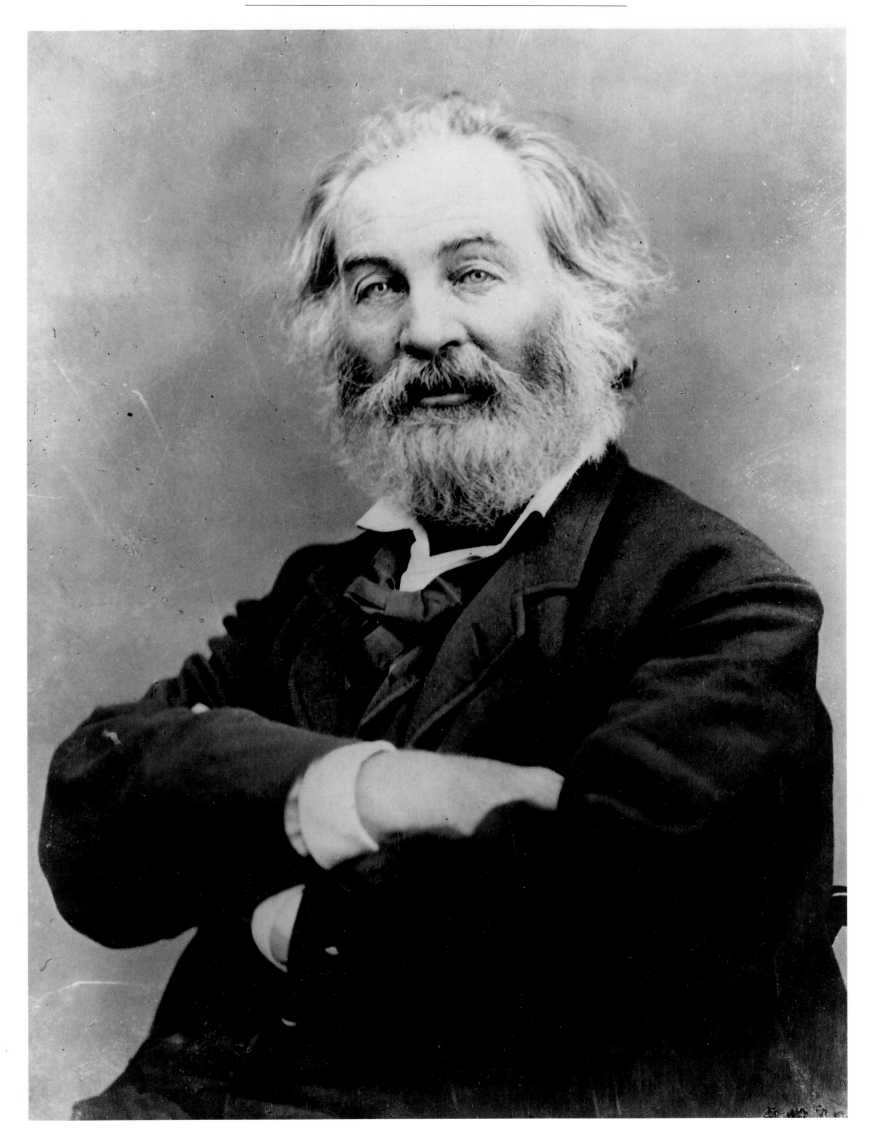

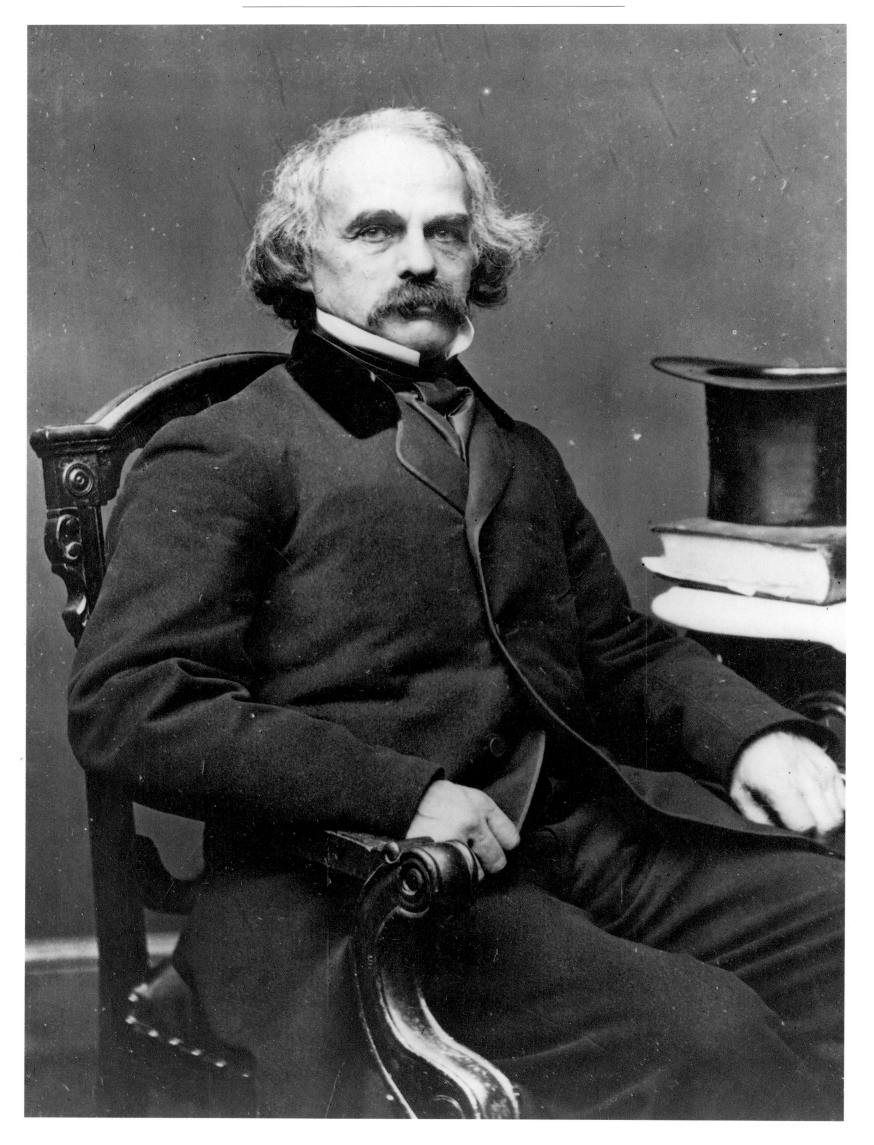

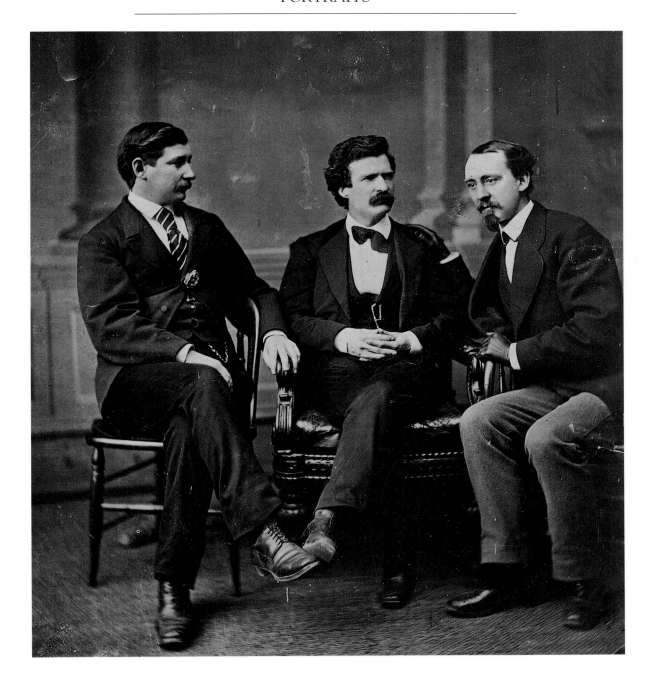

Left: Nathaniel Hawthorne (1804-1864), American novelist.

Mark Twain (Samuel Clemens, 1835-1910), American writer, with friends George Alfred Townsend (l) and David Gray (r), February 7, 1871.

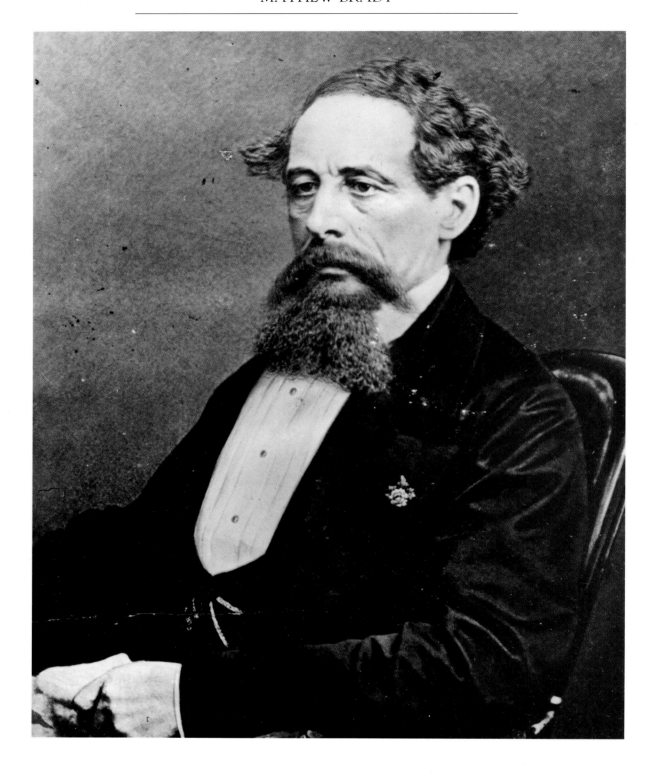

Charles Dickens (1812-1870),
English novelist. Taken in
Brady's New York studio during
Dickens's second trip to
America (1867-8).

Right: Henry Clay (1777-1852),
American politician, lawyer,
congressman, secretary of state.
Photo taken in Brady's Fulton
Street Gallery, 1849.

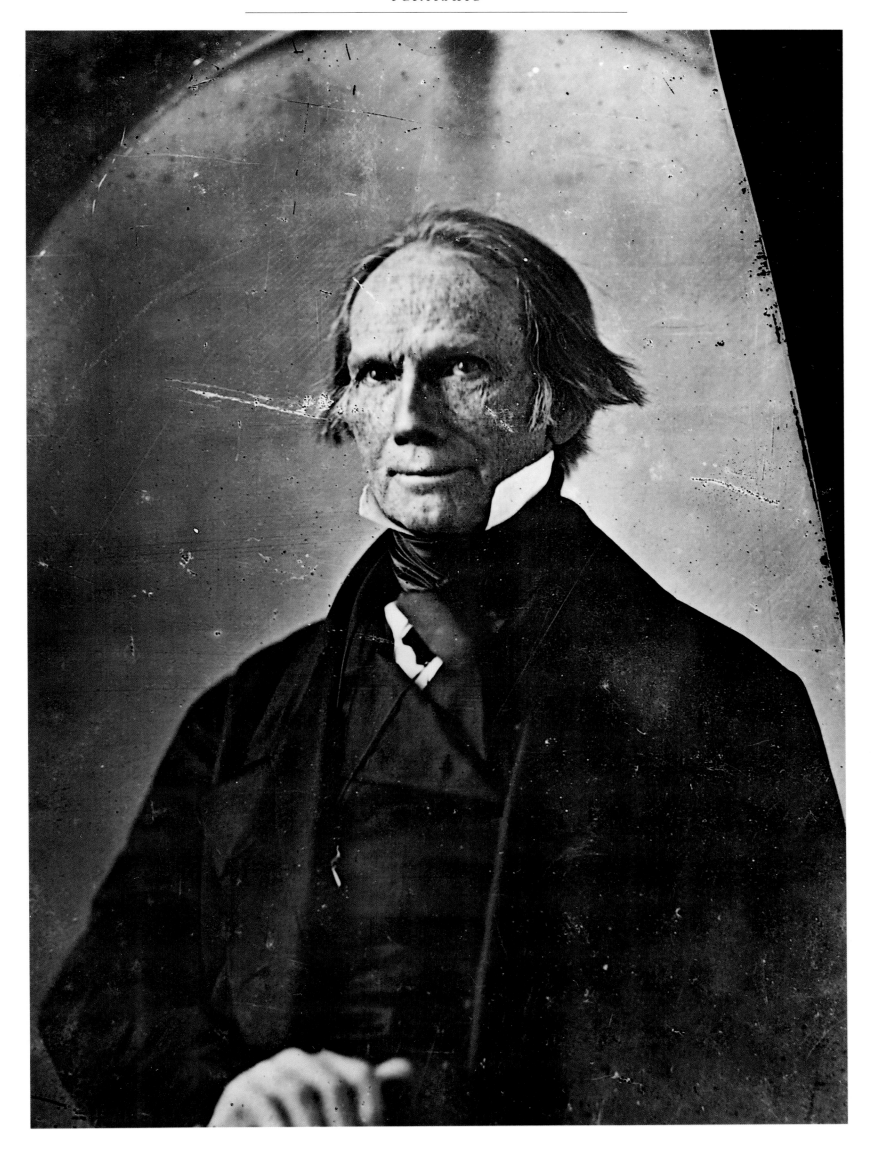

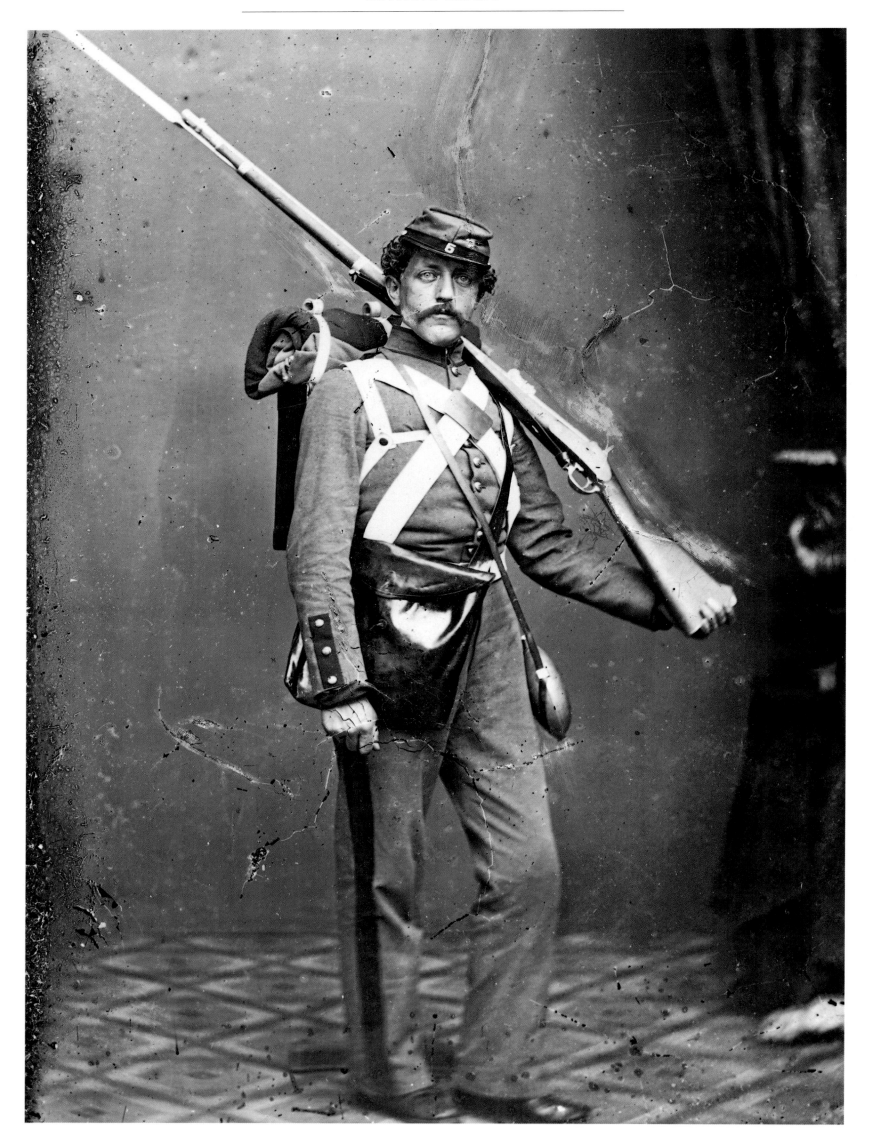

Left: New York State Militia
soldier in grey uniform.

Belle Boyd (1843-1900),
Confederate spy.

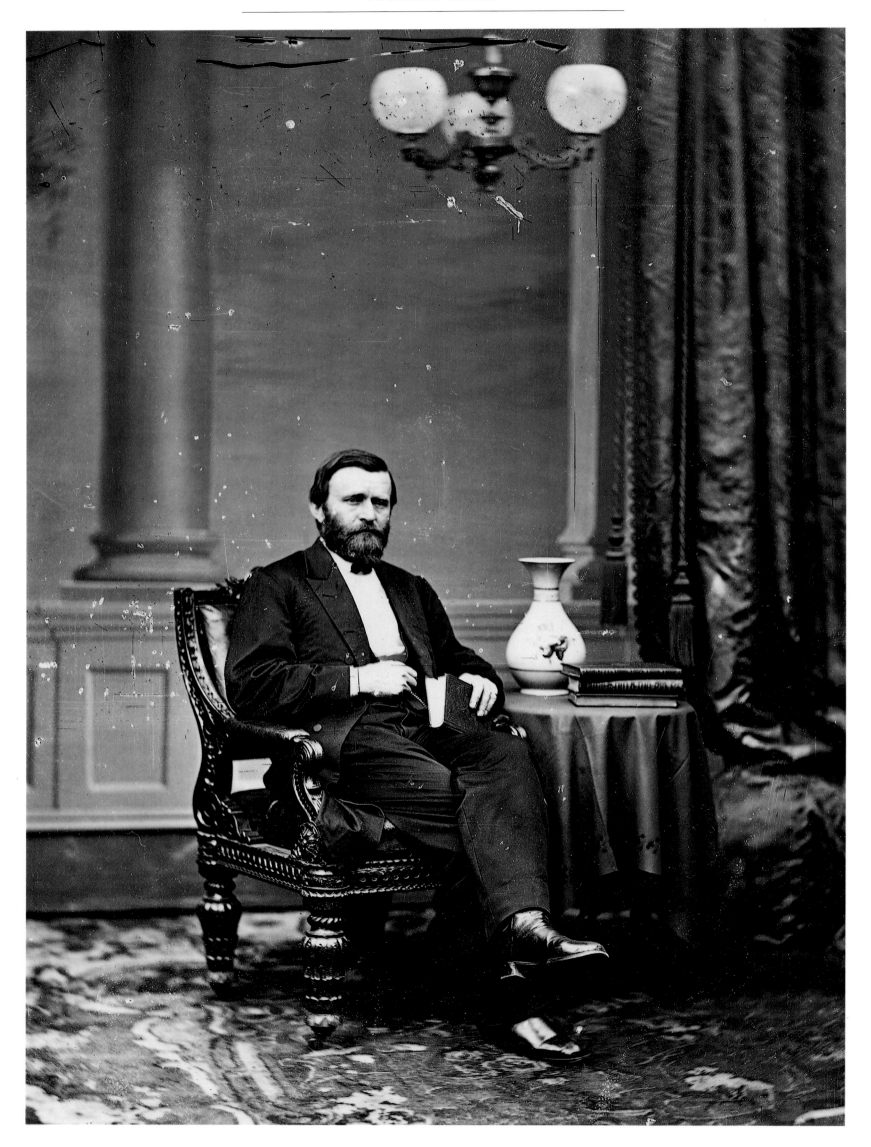

Left: Ulysses S. Grant (1822-1885), Union Army general, 18th President of the United States, c. 1869.

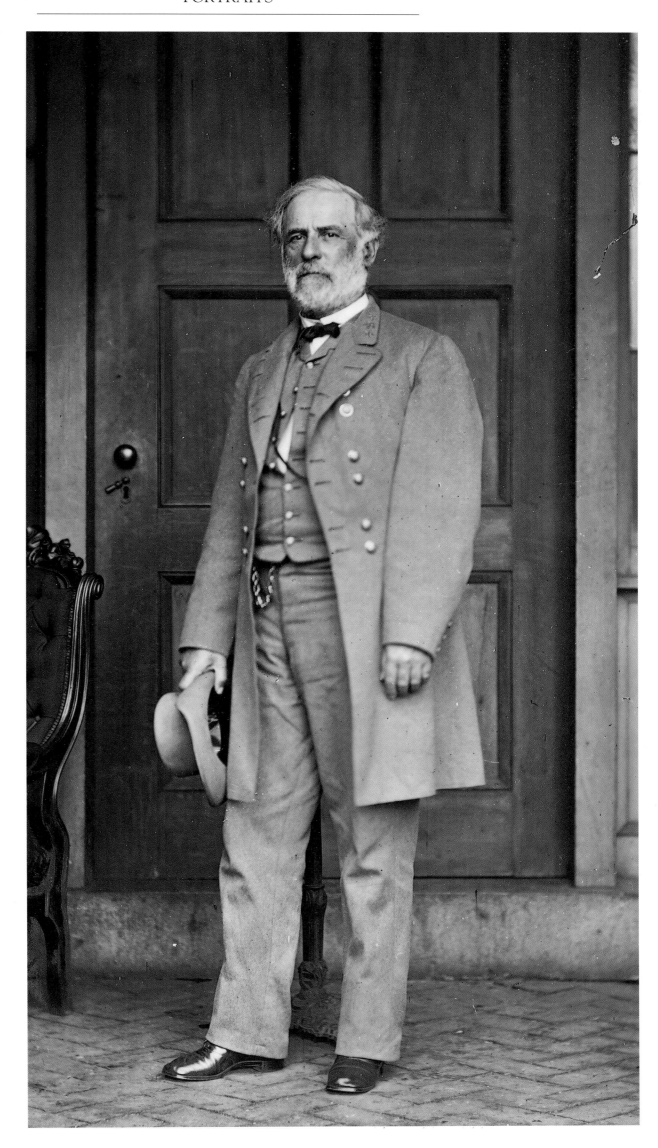

Robert E. Lee (1807-1870), Confederate Army general, president of Washington College. Photo taken at Lee's home in Richmond, Virginia, April 20, 1865.

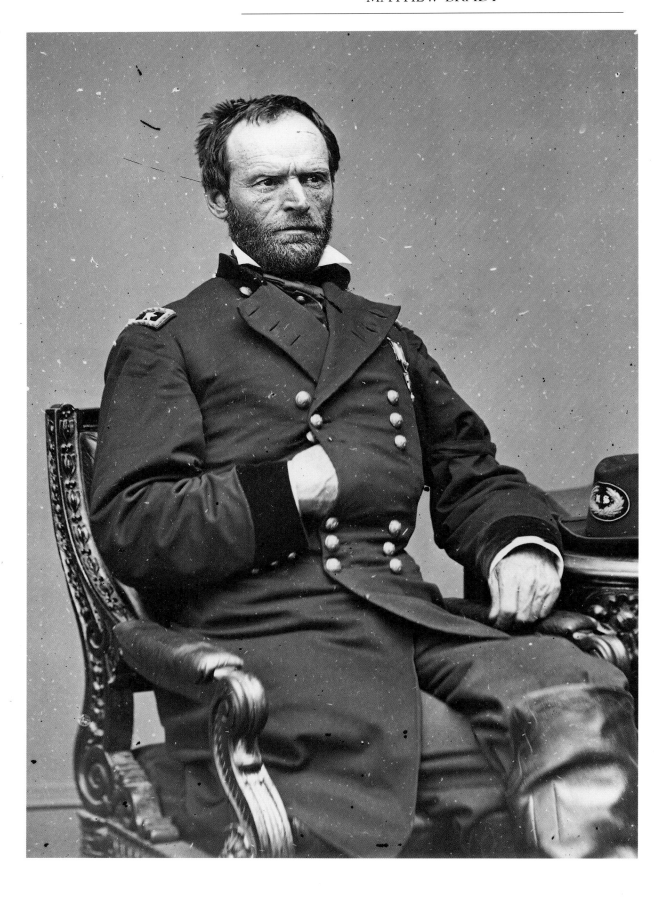

William Tecumseh Sherman
(1820-1891), Union Army
general.

Right: George Armstrong Custer
(1839-1876), U.S. Cavalry
officer, c. late 1860s.

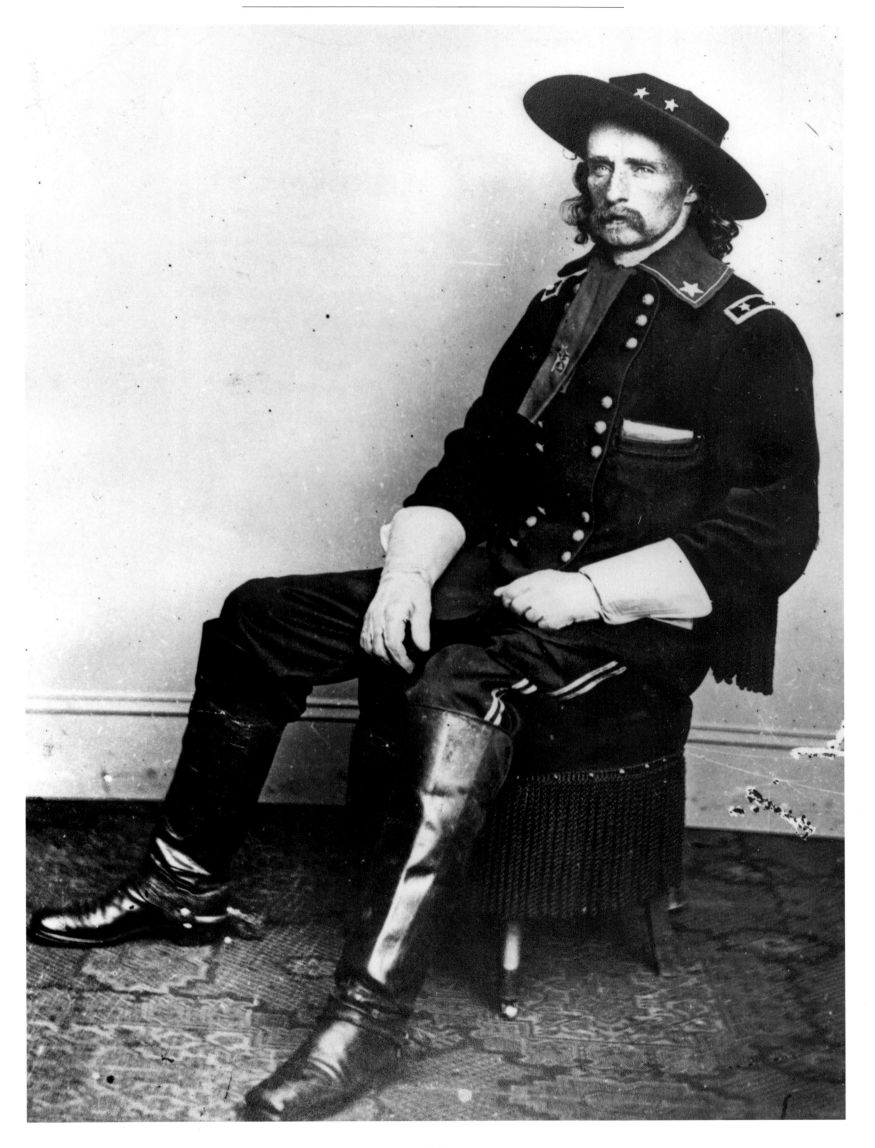

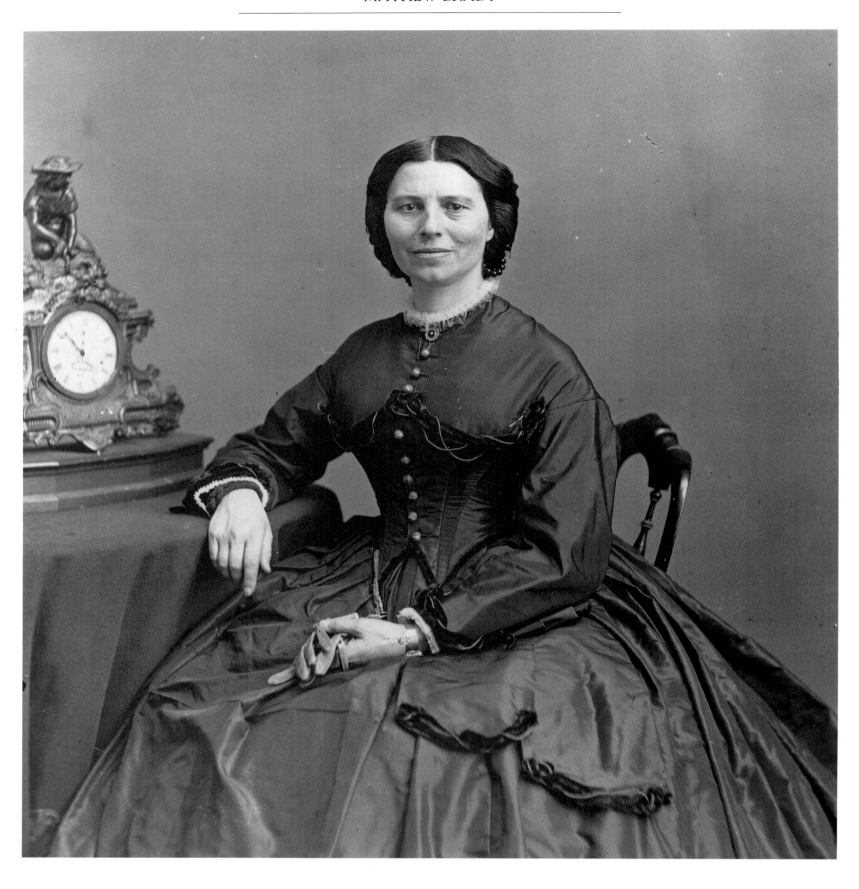

Clara Barton (1821-1912), Civil
War nurse, founder and
president of the American Red
Cross in 1881, n.d.

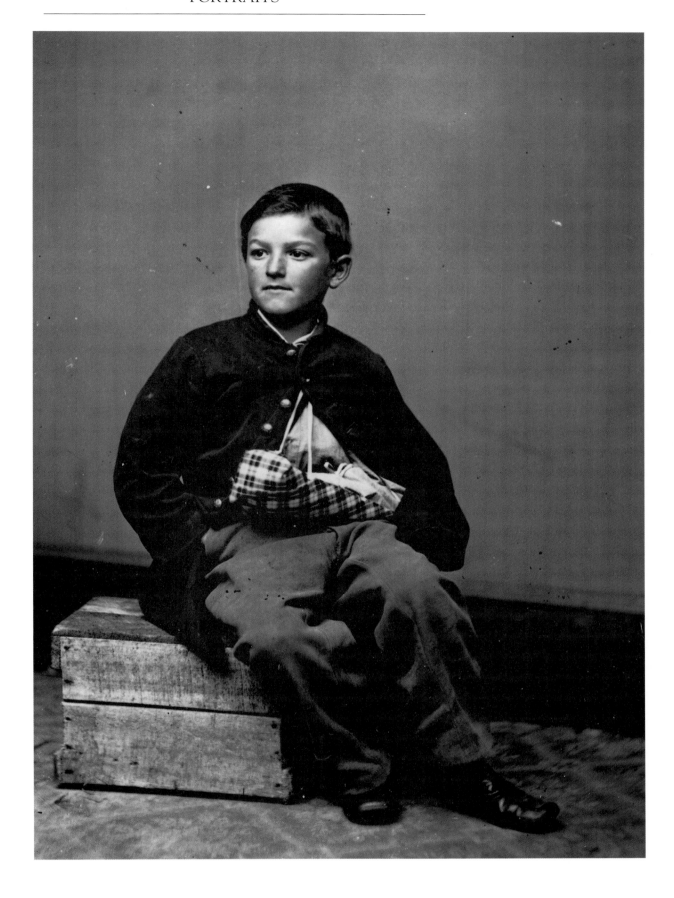

William Black (n.d.), 12-year-old drummer boy, considered the youngest wounded soldier in the Civil War.

37

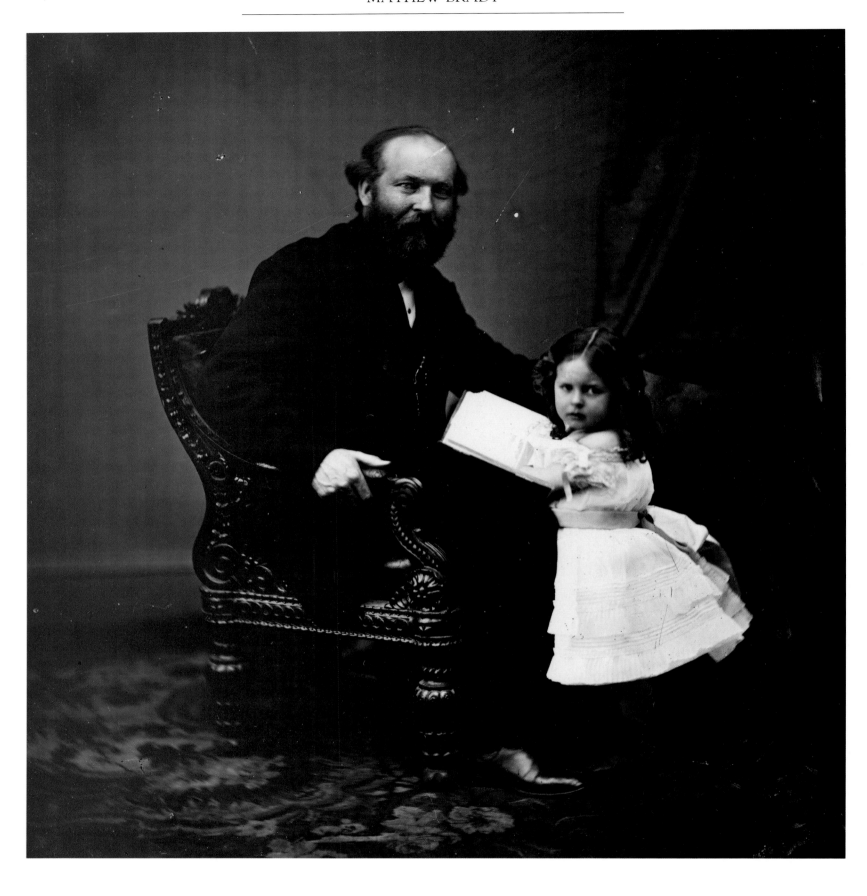

James A. Garfield (1831-1881), professor, soldier, college president, congressman and 20th President of the United States, with his daughter.

Right: Rutherford B. Hayes (1822-1893), American politician, governor, and 19th President of the United States.

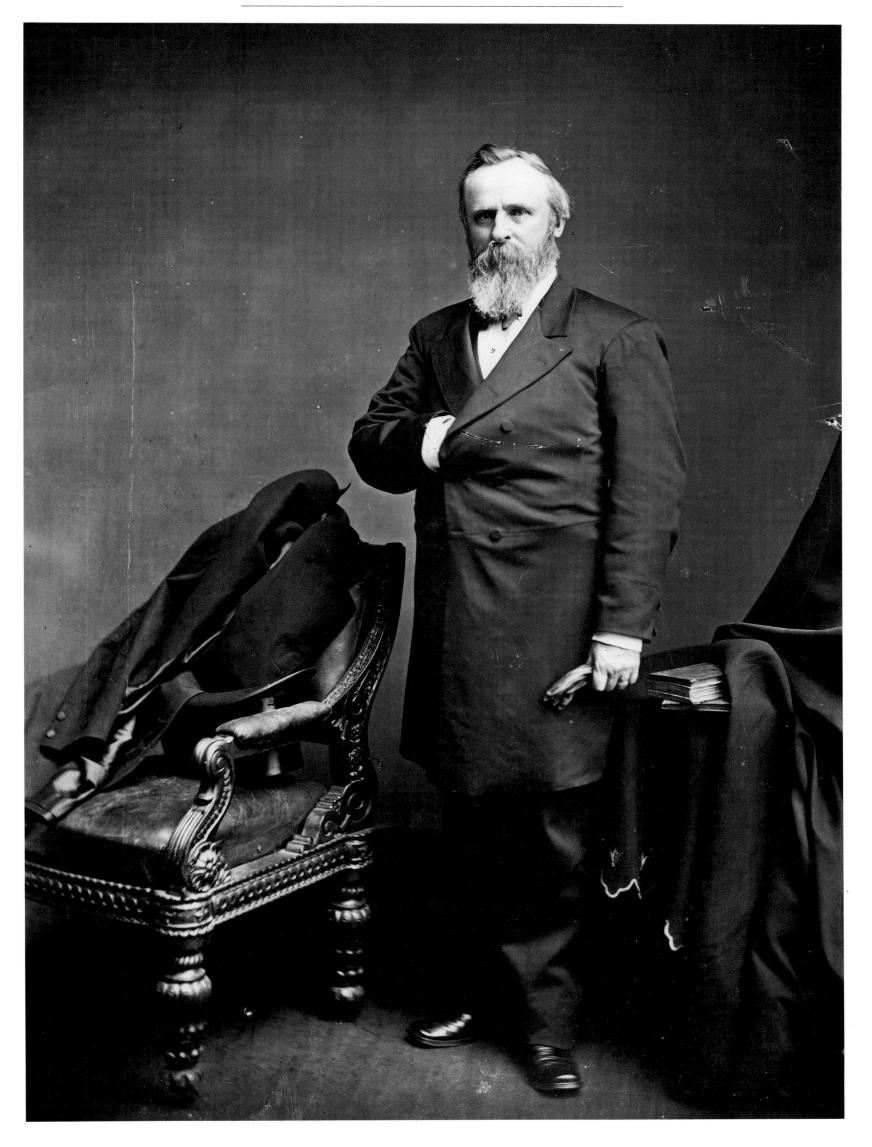

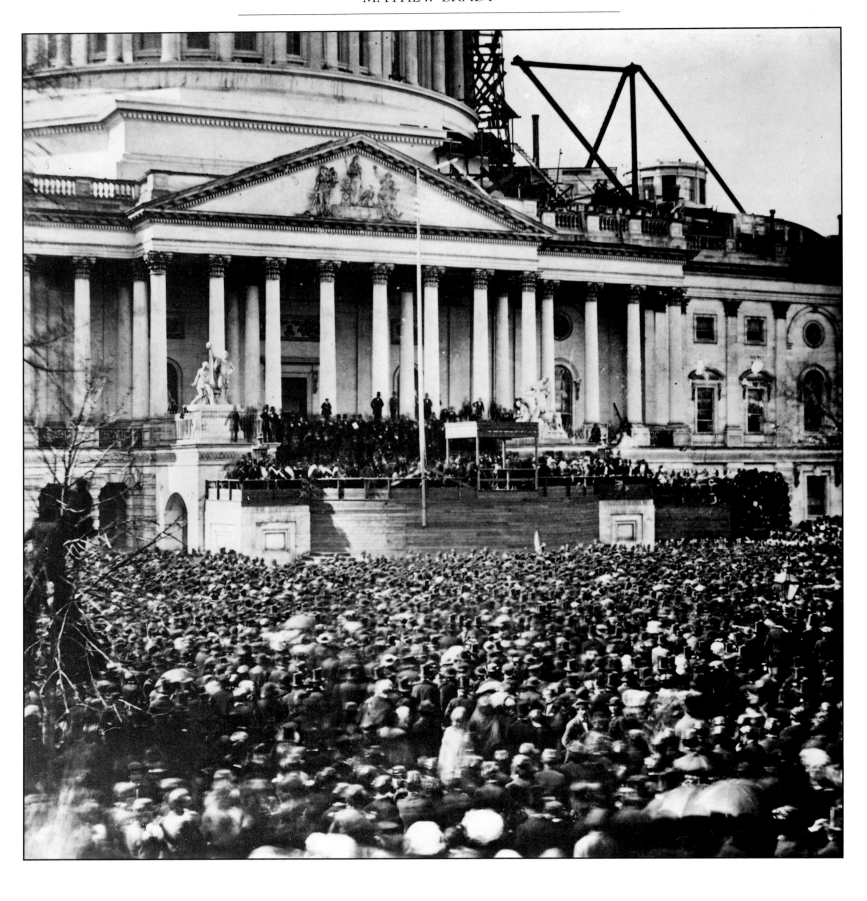

The inauguration of President
Lincoln, Washington, D.C.,
March 4, 1861.

CONTEMPORARY LIFE

Mathew Brady's decision to take few general outdoor shots had nothing to do with technology: after all, Nièpce's first "photograph" was of an outdoor scene, and as early as the 1840s, amateurs and professionals alike were making daguerreotypes of exotic travel destinations, famous buildings, monuments and countless other subjects located out of doors. Brady "specialized" because his interest lay in people, not places, and because the total Brady experience required the technical control and public display only his studio/galleries could provide.

Nevertheless, exceptions do exist. An inauguration or a parade, also, would occasionally lure Brady and his operators away from the studio. It sometimes happened that, when out on such an assignment, they took advantage of the opportunity to document nearby items of interest, such as the Washington Monument under construction or Ford's Theatre, the site of Lincoln's assassination.

There are pictures of New York City toward the end of the war. The population of Manhattan in the 1860s already exceeded 800,000, up almost 300 percent in just 20 years. As is still the case, terrible poverty thrived next to opulence and power. Although parts of Manhattan were still rural in character (and, of course, there were no motor-driven vehicles), Broadway, the street with which Brady was so closely identified, was well on its way to becoming the bustling commercial artery of the city, while rising everywhere were the multi-storied offices and factories that would make New York City "the workshop of the western world."

In contrast to New York, which was already a rival of Paris and London, Washington, D.C. in mid-century was little more than an overgrown country town. Its half-dozen marble government buildings co-existed uncomfortably with grazing cattle, empty lots, unpaved streets and a rank canal which took the place of a decent sewer system. The district's spirit was equally uncertain. Before the Civil War, Congress harbored people planning nothing less than treason, while afterwards, Reconstruction and the impeachment and trial of President Andrew Johnson fostered an atmosphere of greed and fear. Development came slowly to Washington, with the war delaying completion of a number of building projects, including the Washington Monument and the new dome of the Capitol building.

Having already made Lincoln's first official presidential photographs, Brady applied for permission to photograph the inauguration as well. In the face of a number of overt and rumored threats on the president-elect's life, security forces left no stone unturned. A detachment of soldiers guarded the speaker's platform from the moment it was constructed. Sharpshooters perched on nearby rooftops and a battalion of D.C. troops waited in the wings in case of trouble. Brady and his crew showed up with gear in hand, but, despite his reputation and his relationship with Lincoln, he failed to get close enough to make a recognizable photograph of the President.

The occasion of Lincoln's funeral procession again brought Brady outside with his gear, as did the Grand Review, the postwar victory parade down Pennsylvania Avenue. Exact authorship of any "Brady" photograph is always open to question, but never more so than the pictures he made away from his studio. Brady enjoyed a working relationship with Edward Anthony, owner of E. and H. T. Anthony, later Ansco, the largest photographic supply company in the nation. Each surely took pictures for the other and, over the years, Anthony acquired many of Brady's negatives. Possibly Anthony, or perhaps Levin Handy, Brady's nephew, photographed the Grand Review for Brady's collection.

Contemporary life is also reflected in the faces of cultural notables such as theatre stars, dancers, singers, actors and writers who, in addition to politicians and military men, left their images for posterity on Brady's plates. The style of dress, the choice of subject, the mere appearance of certain people in New York or Washington at that time all provide valuable clues about life in the United States during the mid-nineteenth century.

Consciously or not, Brady left it for his successors, often people who had once worked for him, to document a wider slice of contemporary life. Alexander Gardner sent a photographic team to Peru after the Civil War and he himself took many fine pictures of the Kansas frontier. Timothy O'Sullivan, another Brady protégé, achieved fame for his photographs of the raw beauty of the American West. Some later photographers expanded their subject material to include laboring people and the poor, while still others used the now not-so-new technology to express their spiritual and artistic inclinations. But all could admit that they owed a great deal to the first American who displayed the power of photography – Mathew Brady.

United States Capitol Building
in Washington, D.C. before
completion, c. 1858.

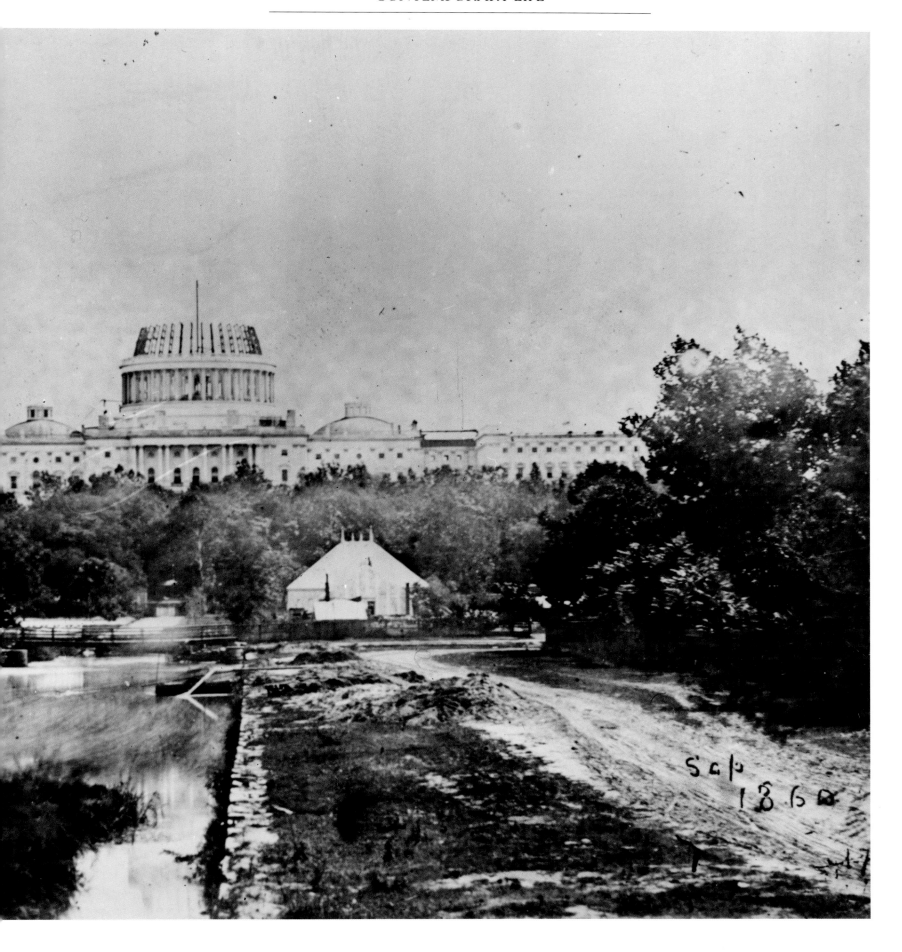

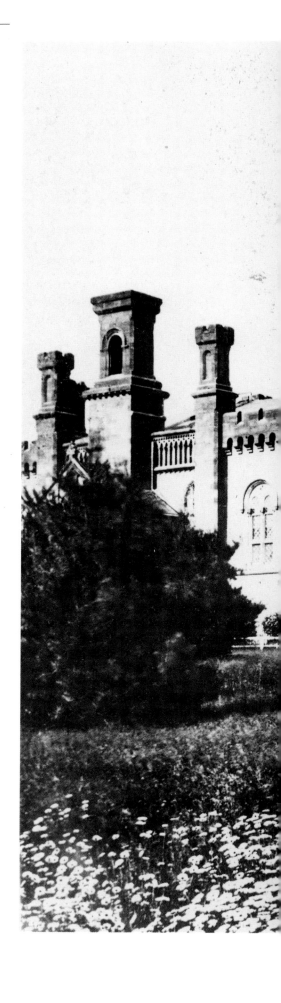

The Smithsonian Institution,
Washington, D.C., c. 1860.

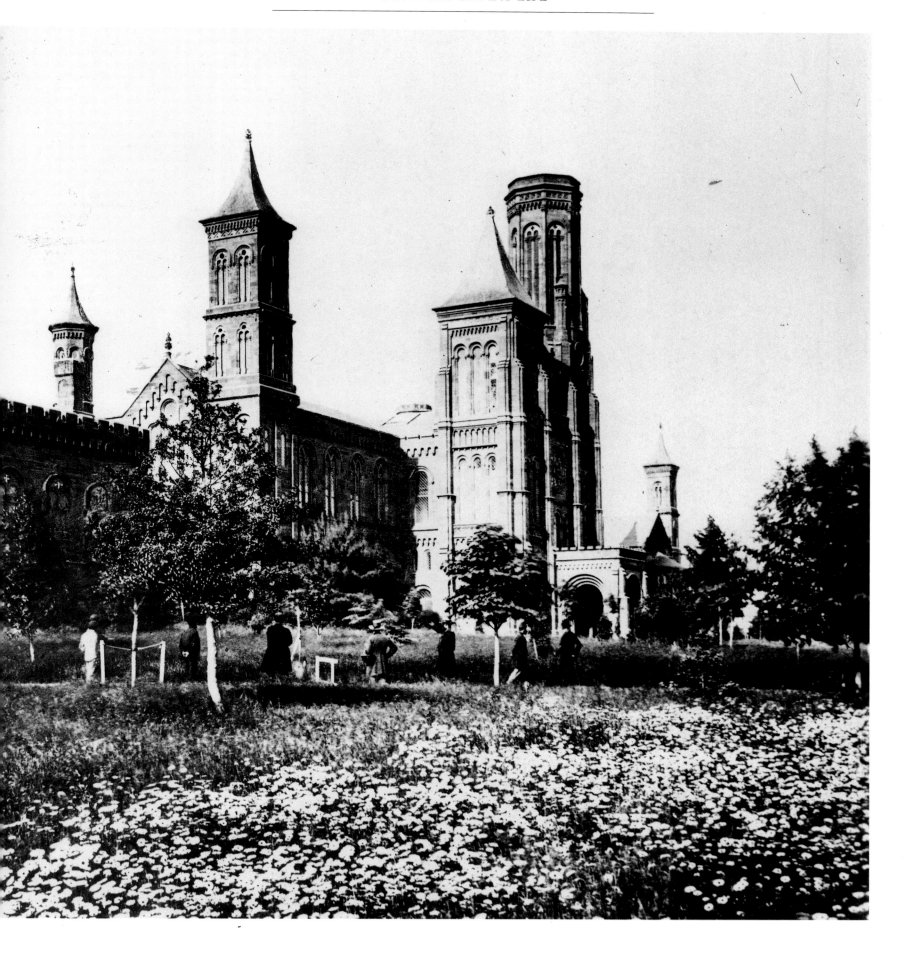

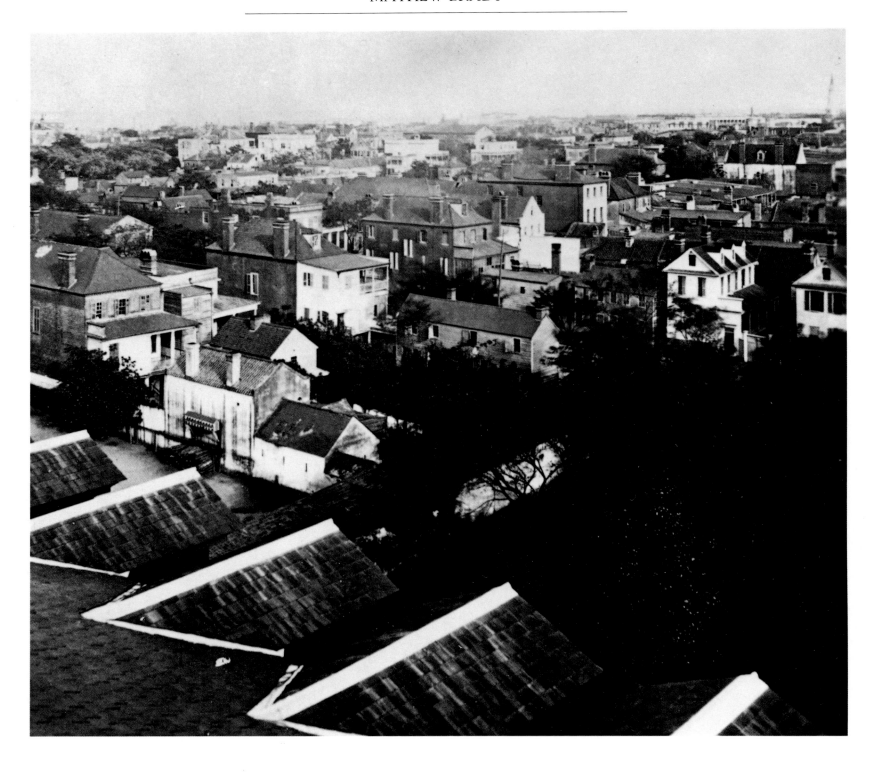

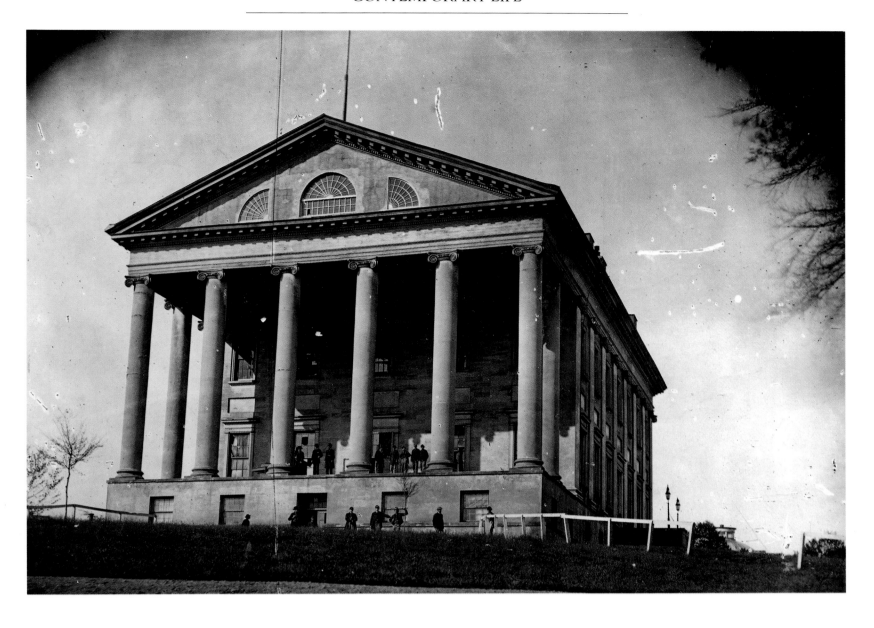

Left: Bird's-eye view of the city
of Charleston, South Carolina,
c. 1864.

The Virginia State House, once
the Capitol of the Confederacy,
in Richmond, Virginia.
Mathew Brady stands fifth from
the right on the porch, 1865.

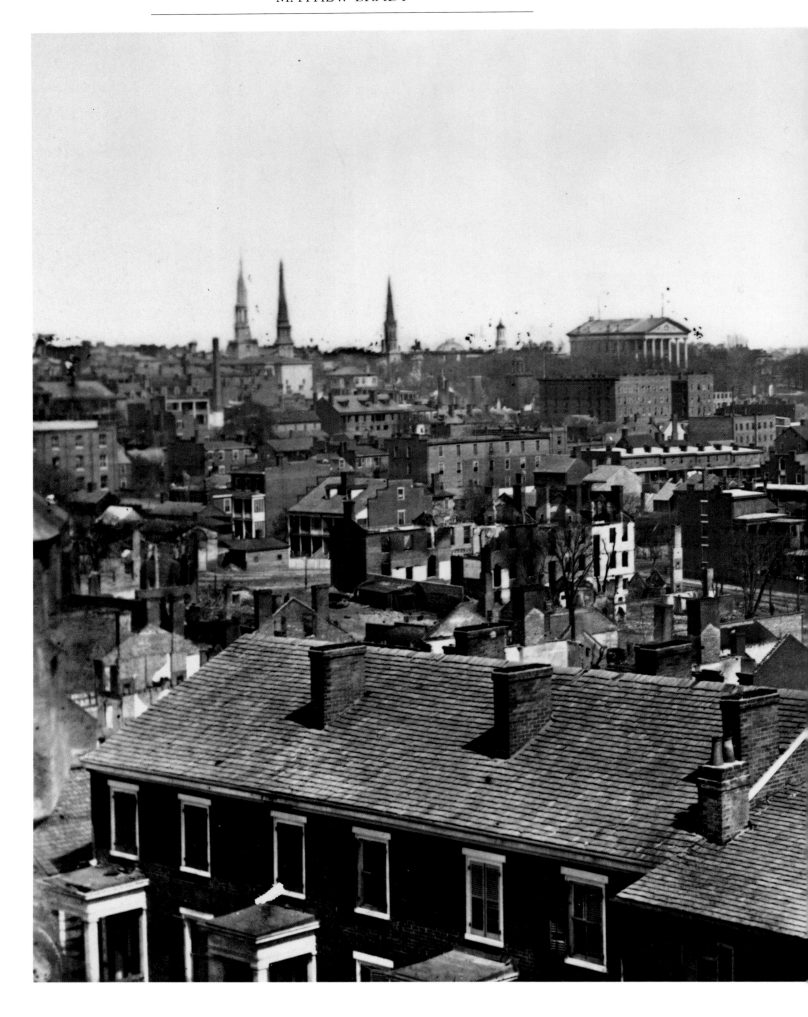

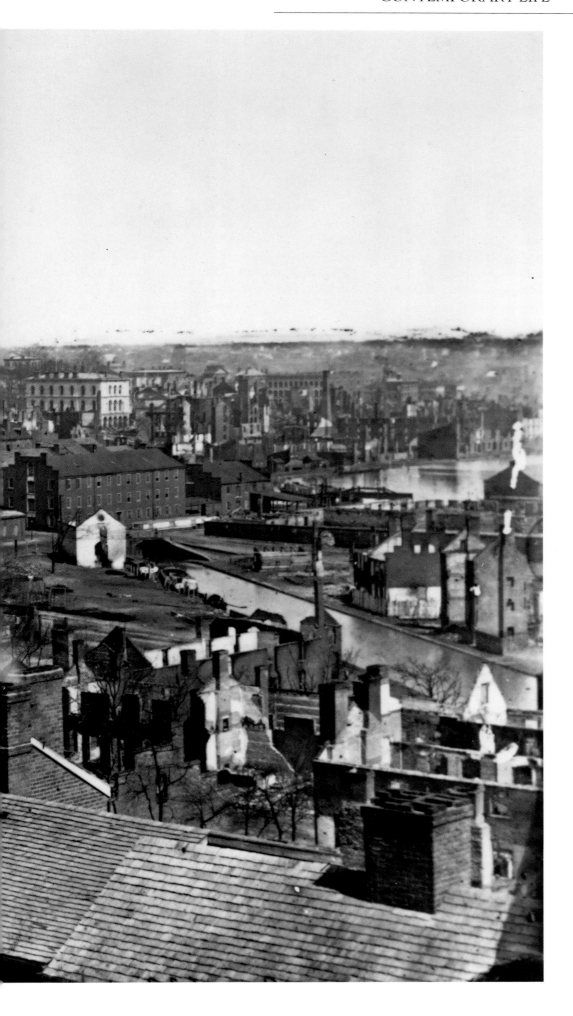

Overall view of Richmond,
Virginia, towards the end of
the Civil War.

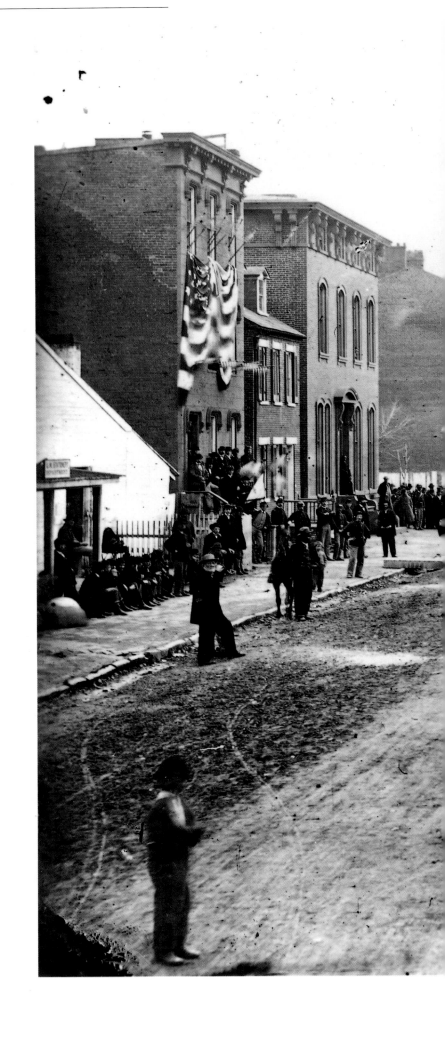

The 1st U.S. Veteran
Volunteer Infantry, F Street,
Washington, D.C., March
1865.

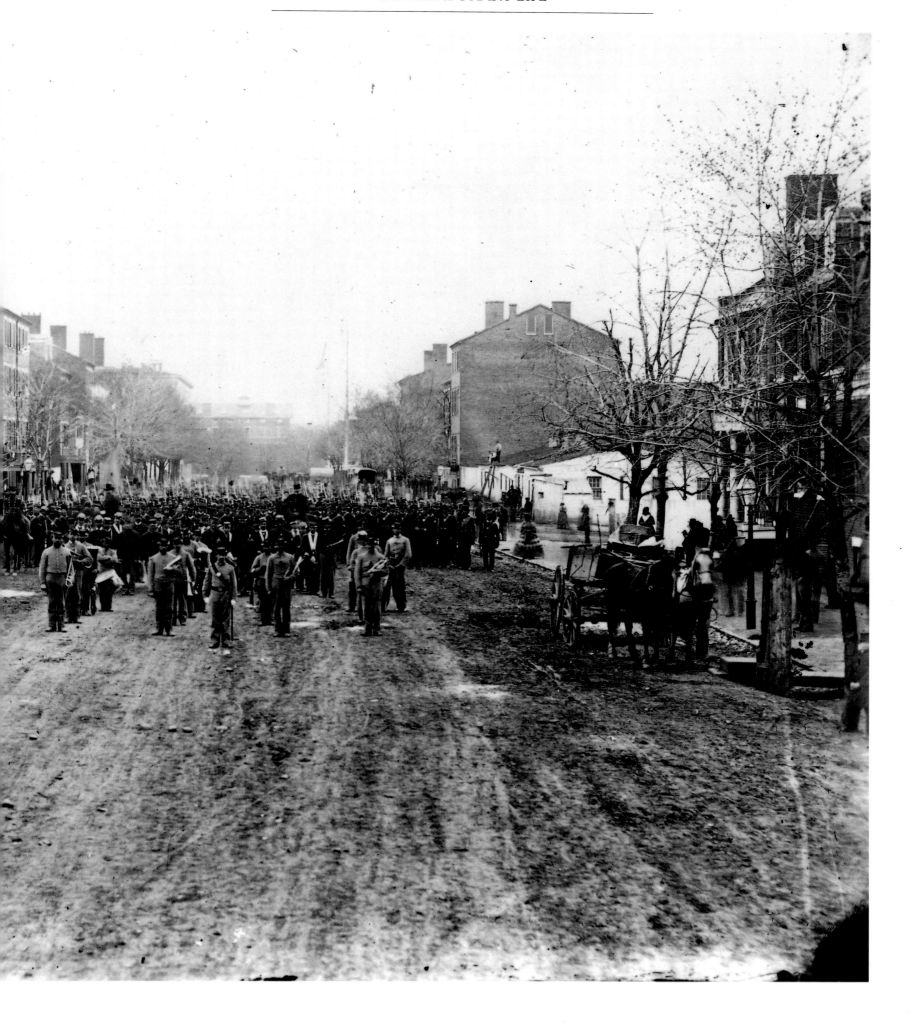

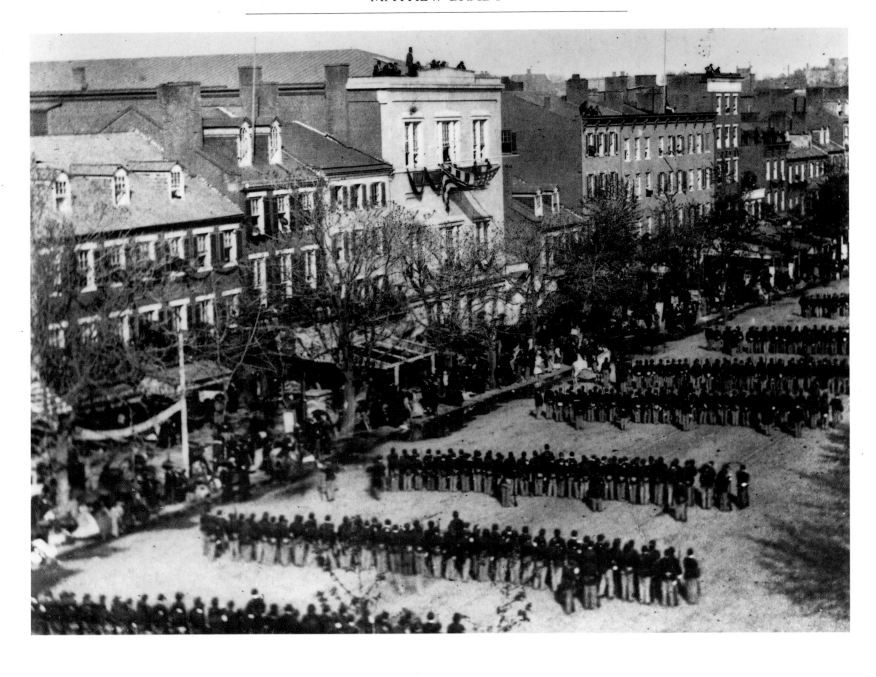

Lincoln's funeral procession
down Pennsylvania Avenue,
Washington, D.C., 1865.

Right: Laura Keene (1826-
1873), American actress and
first female theater manager,
starred in *Our American Cousin*
at Ford's Theater the night
President Lincoln was shot.

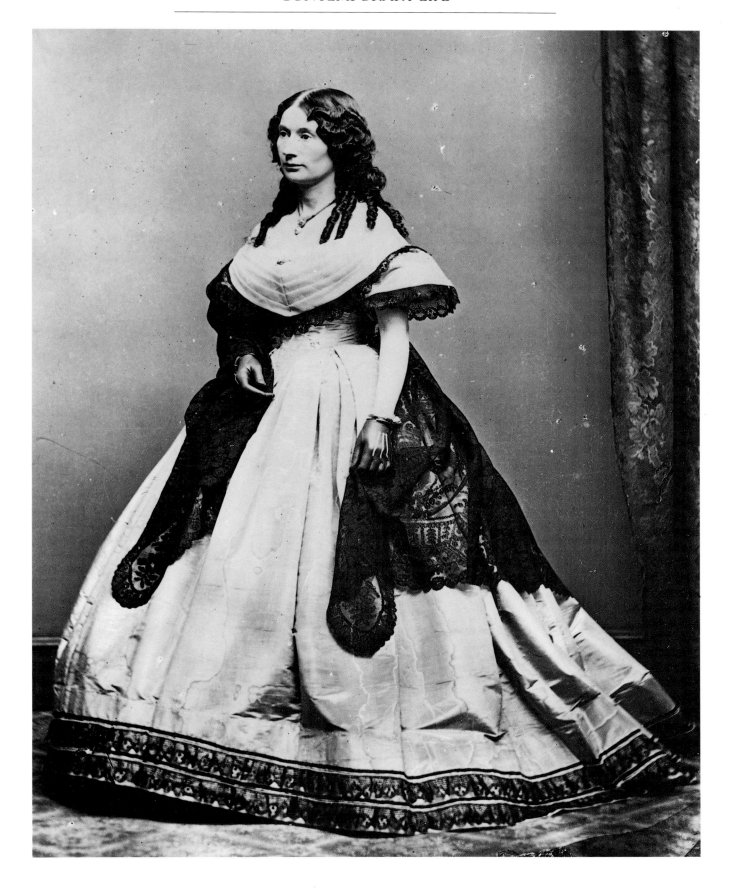

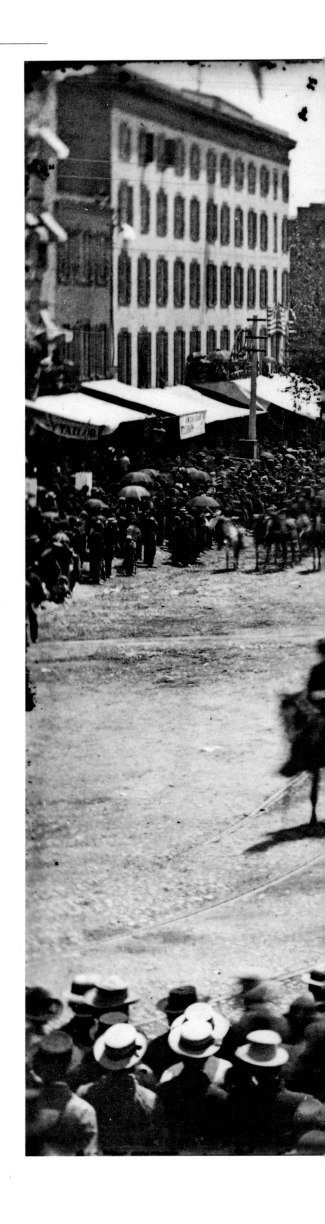

The Grand Review of the
Union Armies, part of the
victory celebrations in the
North that took place after the
surrender of the South, May
24, 1865.

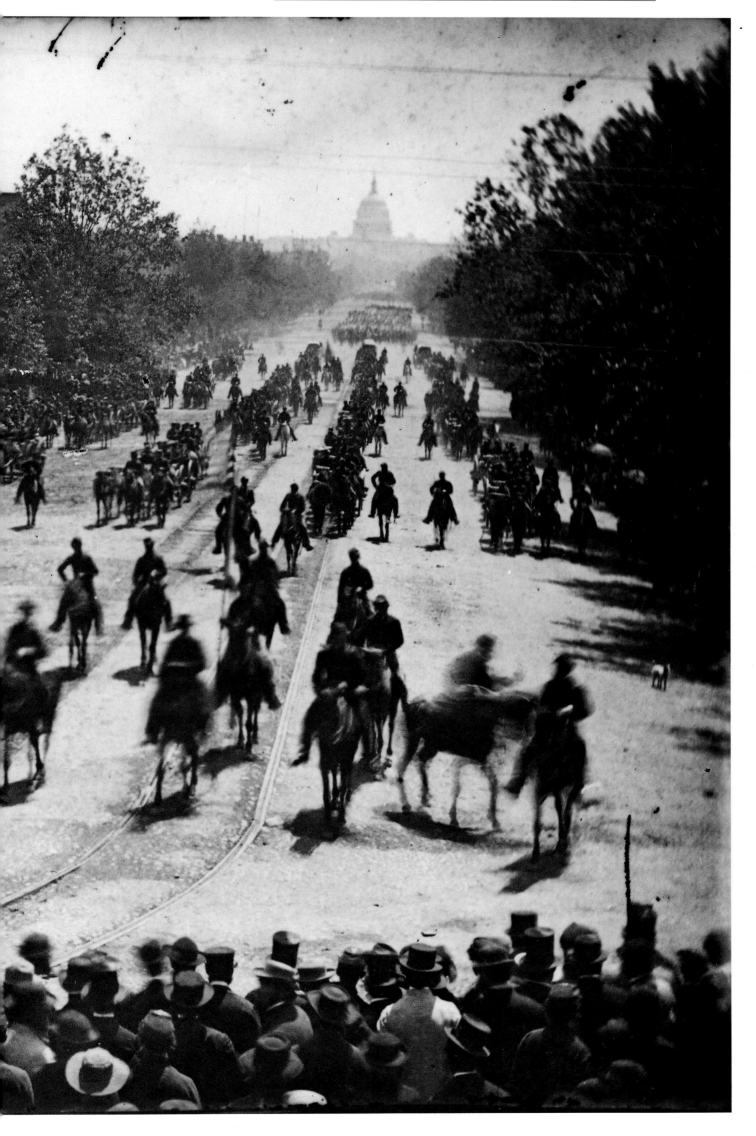

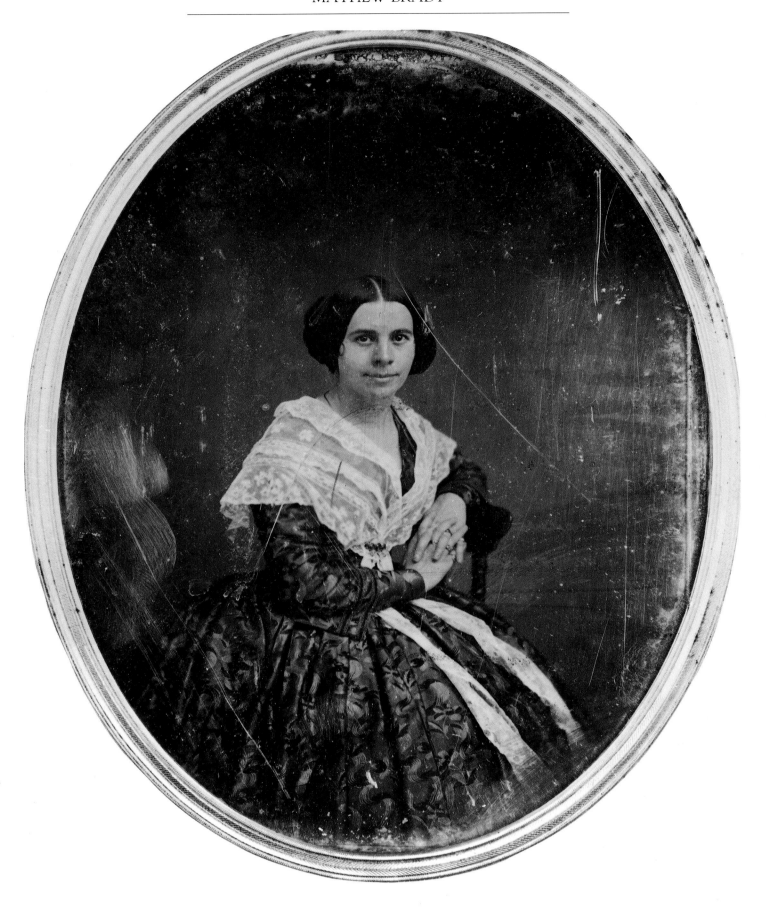

Jenny Lind (1820-1887),
Anglo-Swedish soprano opera
star, known as "the Swedish
Nightingale." Daguerreotype,
c. 1850.

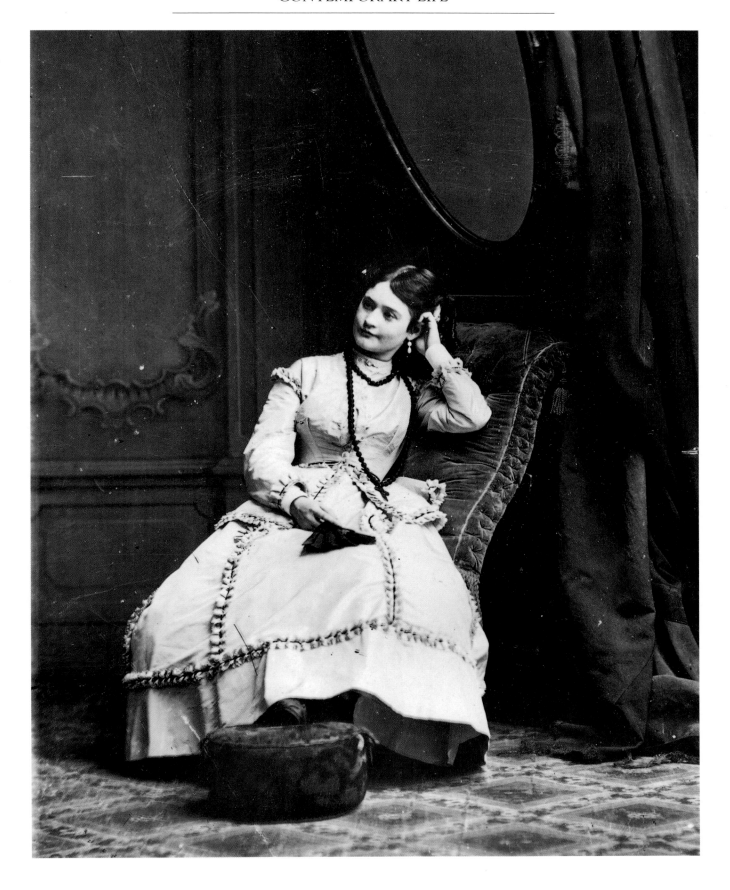

Agnes Robinson (n.d.),
American actress, wife of
American actor/playwright
Dion Boucicault, c. 1863.

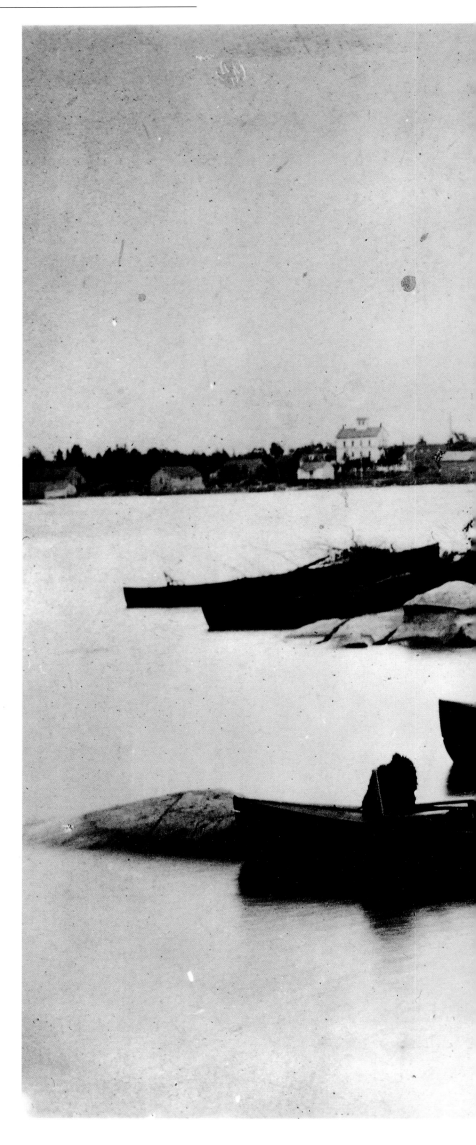

Chester Arthur (1829-1881),
21st President of the United
States, during a fishing trip,
n.d.

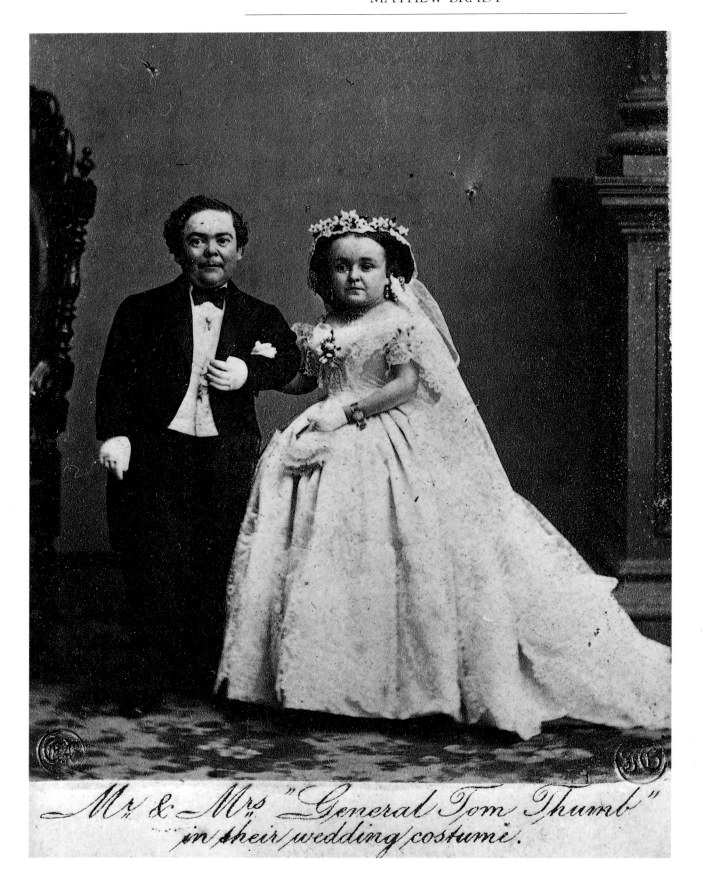

Mr & Mrs "General Tom Thumb"
in their wedding costume.

General Tom Thumb (Charles
Stratton, 1838-1883) of P.T.
Barnum's Circus with his bride
Mercy Lavinia Warren Bump
(1841-1919) in their wedding
attire, 1863.

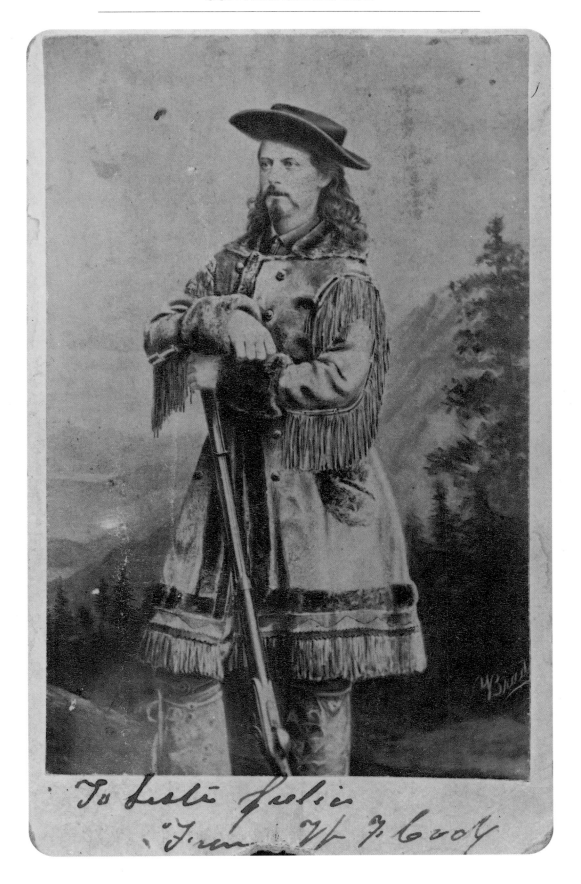

William F. "Buffalo Bill" Cody
(1846-1917), army scout,
buffalo hunter, Indian fighter,
showman, c. 1872.

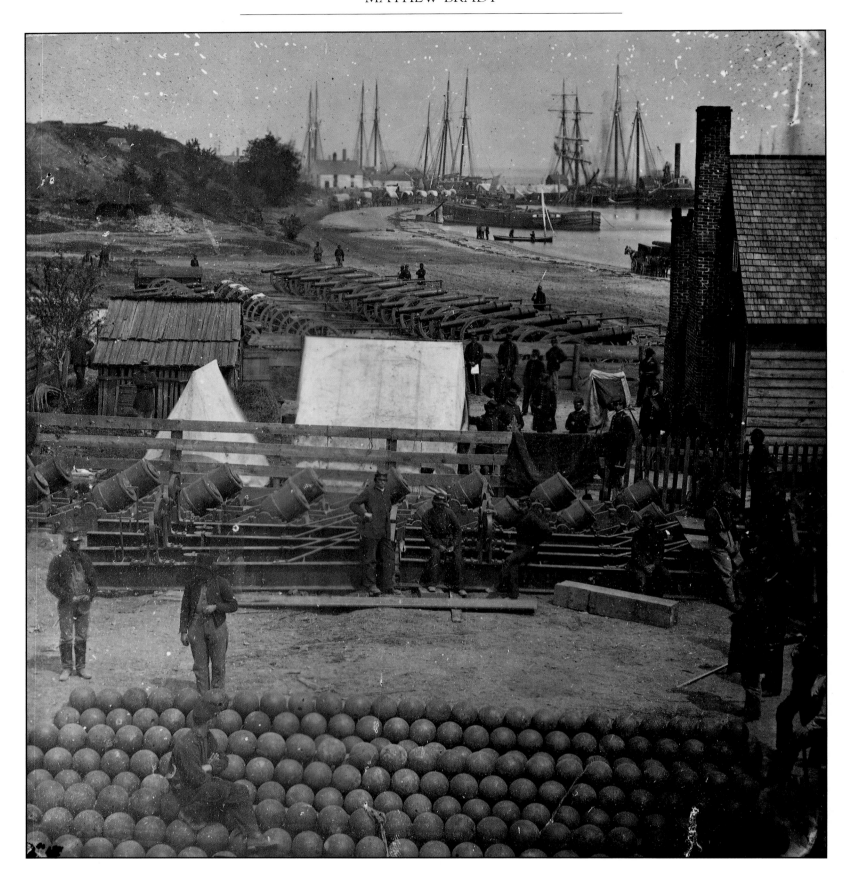

Guns and munitions of
McClellan's Army of the
Potomac at Ship Point near
Larner Wharf after the fall of
Yorktown, Virginia, May 1862.

BATTLE SCENES

In 1851 the British inventor William Henry Fox Talbot photographed, in the light of a sudden electric flash, a page of *The Times* he had fastened to a revolving wheel. His experiment disproved the popular idea that motion could never be captured on film. However, it was not until the 1870s that action photography really came of age. During this decade Eadweard Muybridge, an industrial photographer and inventor of one of the first camera shutters, successfully captured a racehorse in motion, using shutter speeds of between 1/125 and 1/1,000 of a second.

For Brady's Civil War crews motion photography was still a dream. With available technology and the wet-plate process not yet fast enough to permit quality action shots, pictures of actual battles are extremely rare. The contemporary viewer used to live footage may be a bit slow to appreciate the extent to which Civil War photographs do capture the look and feel of war, despite the absence of charging troops, bursting shells, rearing horses and falling men. They give us the stillness just before or just after battle; the massive fortifications; the heavy equipment; prisoners; refugees; and, inevitably, the destruction of lives and property.

The Civil War was the last time major military campaigns occurred in the eastern United States. America's more recent wars all took place far from home, but the battlefields of the Civil War were as familiar at the time as the local farm or village – in fact, they *were* the local farm or village! One reason why the Union defeat at Bull Run in 1861 was so devastating was that retreating soldiers found their way blocked by hordes of spectators who had come from Washington to watch the action, as though out for a picnic. It is this juxtaposition of otherwise peaceful scenes with the image or knowledge of incredible slaughter and destruction which produces the powerful effect of so much of Civil War photography.

Brady personally attended a number of the war's major battles. He watched the Battle of Fredericksburg in December 1862. While photographing the camps and countryside several days earlier, Brady and his men learned that their collodion plates deteriorated more slowly in low temperatures; this meant that photographers could take as long as an hour between coating and developing, instead of the usual 10 minutes or so. On the other hand, working in an unheated wagon and mixing chemicals in the bitter cold was difficult at best.

On the day of the battle the temperature hovered close to zero. Union General Burnside sent wave after wave of soldiers against General Lee's entrenched Confederates, only to see most of them cut down. Almost 13,000 bluecoats and over 5,000 Confederates died that day. Early the next morning, Burnside asked for a brief truce to collect his wounded and bury his dead. Brady and his companions seized this occasion to do their work, this time amid the frozen bodies lying on a stark and grim field.

Brady returned to Fredericksburg the following spring. From the yard of a house outside of town he and his assistant watched what looked like a repeat of the Burnside disaster, except that this time the Federals breached the entrenchment at Marye's Heights and drove the rebels back. Quickly, Brady reached the scene with his camera and big, brass-barreled Harrison lens, making pictures of dead greycoats, Confederate fortifications, and what remained of the Washington Artillery, disabled by a direct hit from the Second Massachusetts siege guns planted across the river at Falmouth.

Other battles Brady personally covered included Sharpsburg (Antietam); Gettysburg, the decisive battle of the war (he missed the dedication of the cemetery there four months later); and Petersburg. It was near Petersburg, in June 1864, that Brady almost lost his life. He asked Captain James Cooper of Battery B, First Pennsylvania Light Artillery, for permission to take a picture of the battery. Cooper agreed and gave the order to load and fire to make the shot more realistic. Confederate soldiers watching from a distance were no more aware that the scene was staged than were Cooper's men. Convinced that they were about to be fired upon, the rebels launched a preemptive attack. With shells falling all around, the photographers coolly continued their work. Soon, finding their fire unanswered, the greycoats ceased their attack and Brady was free to develop his plate.

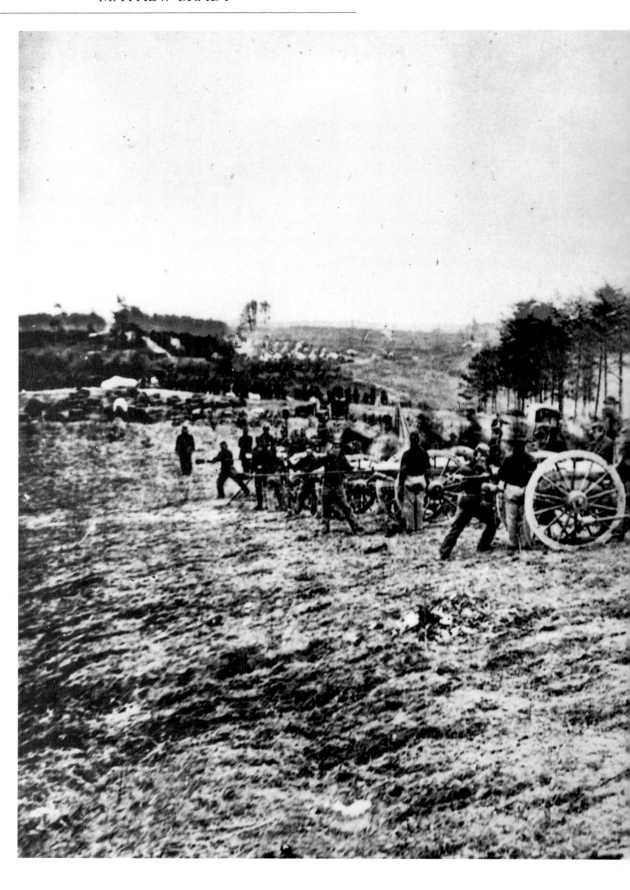

One of the first photographs of
the Union Army in combat at
the First Battle of Bull Run,
July 20, 1861.

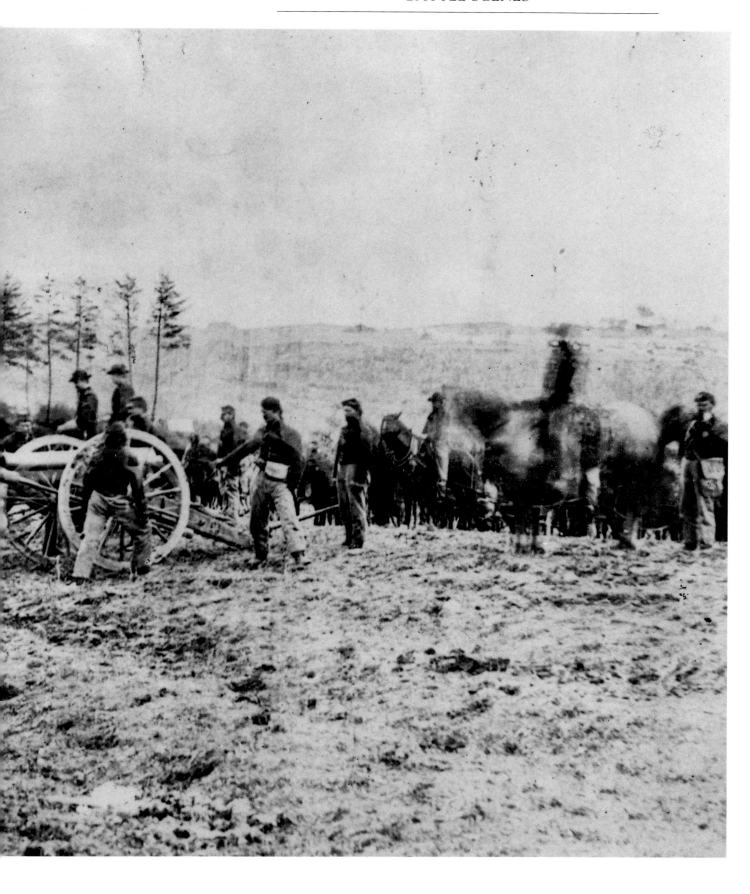

Overleaf: General view of the
96th Pennsylvania Infantry
Regulars drilling at Camp
Northumberland, 1861.

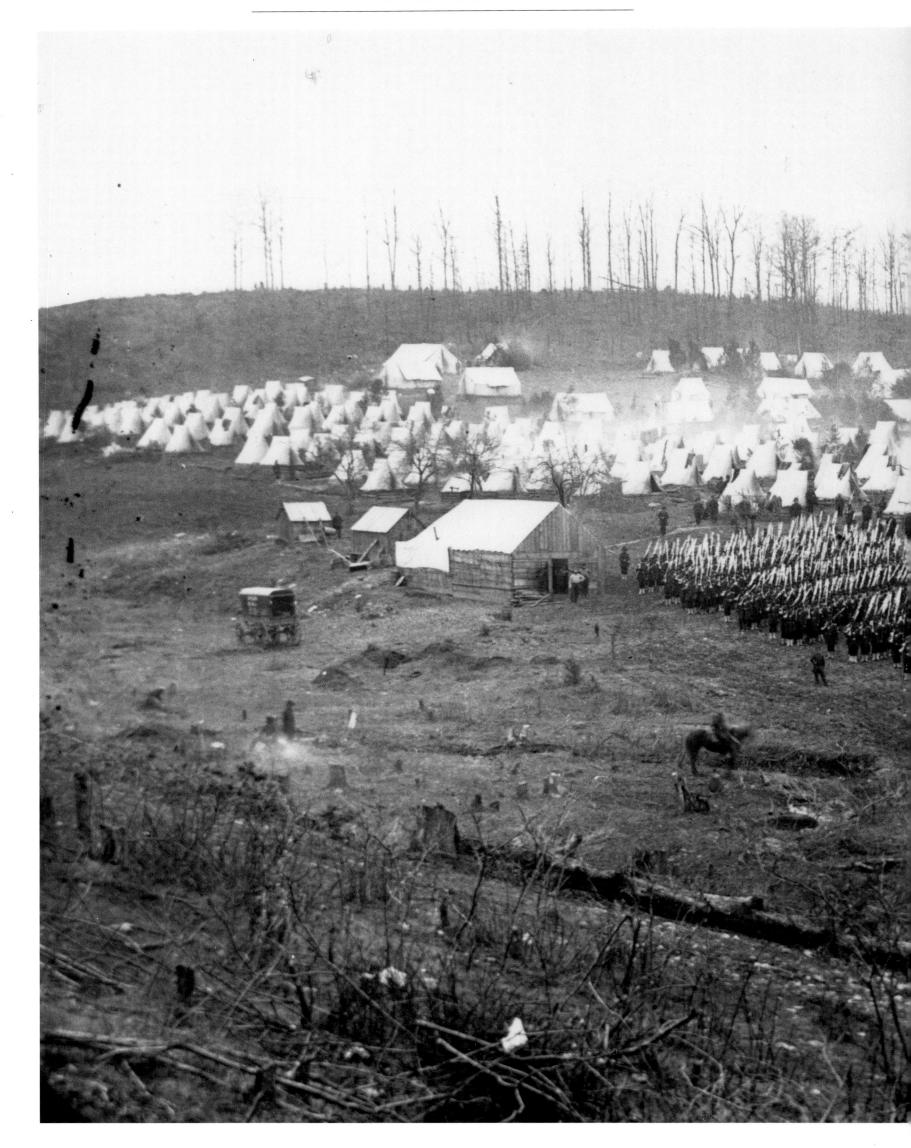

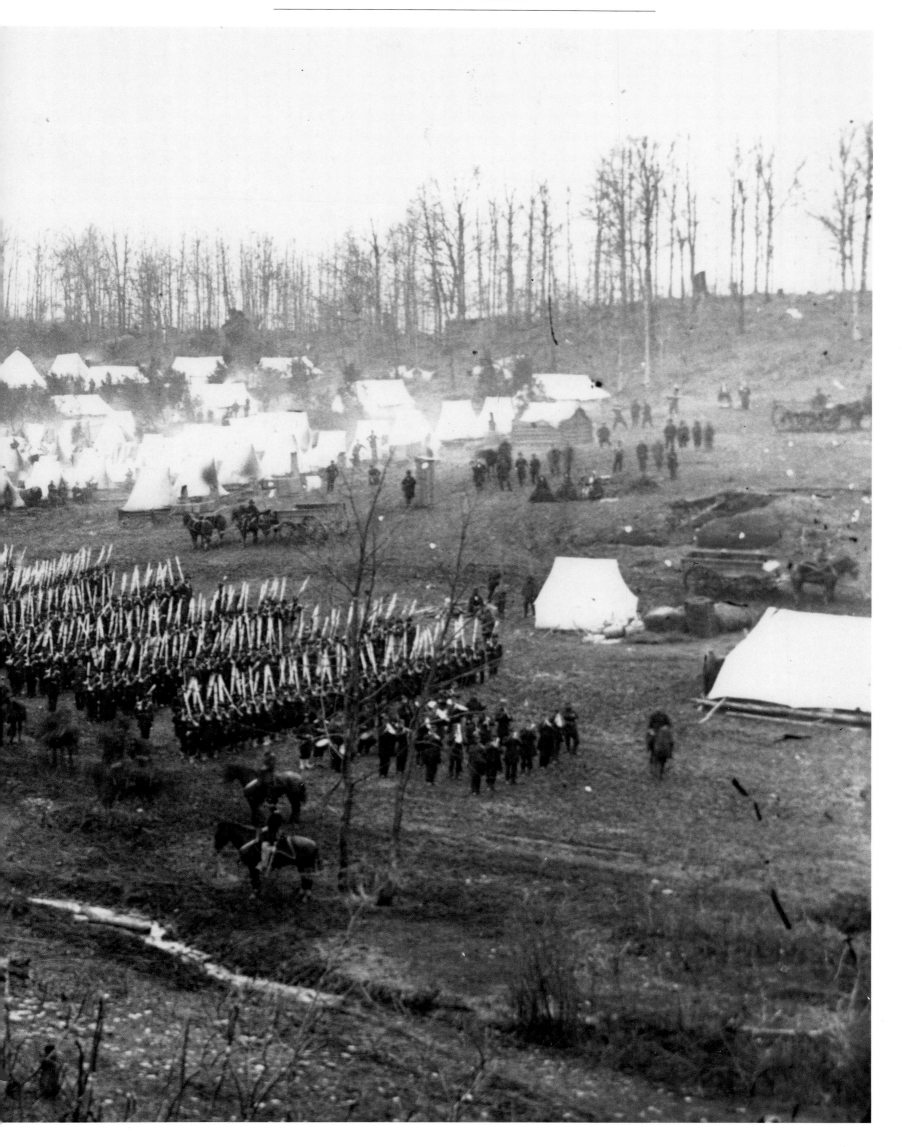

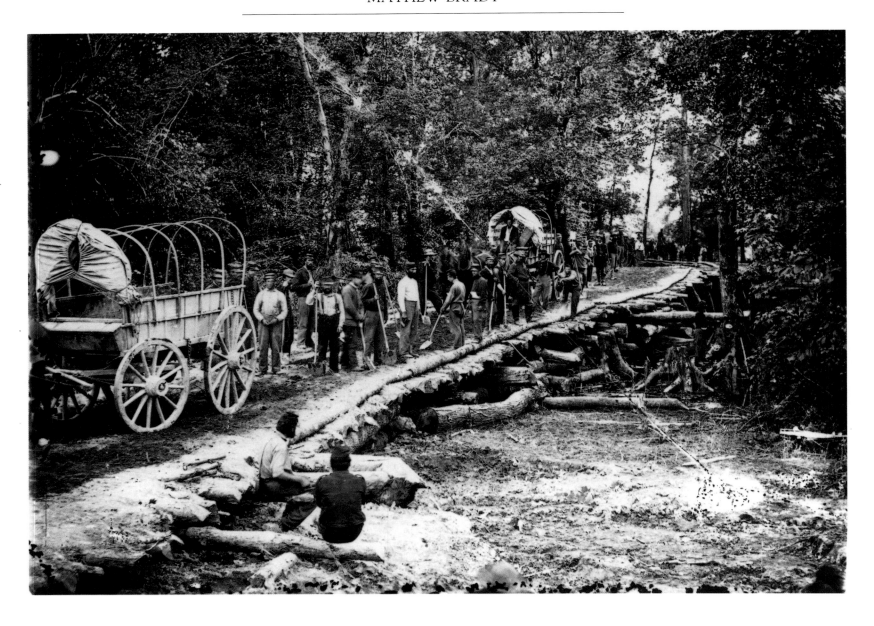

Grapevine Bridge, built by
Union engineers on the
Chickahominy Creek, Virginia,
prior to the Seven Days
Campaign, 1862.

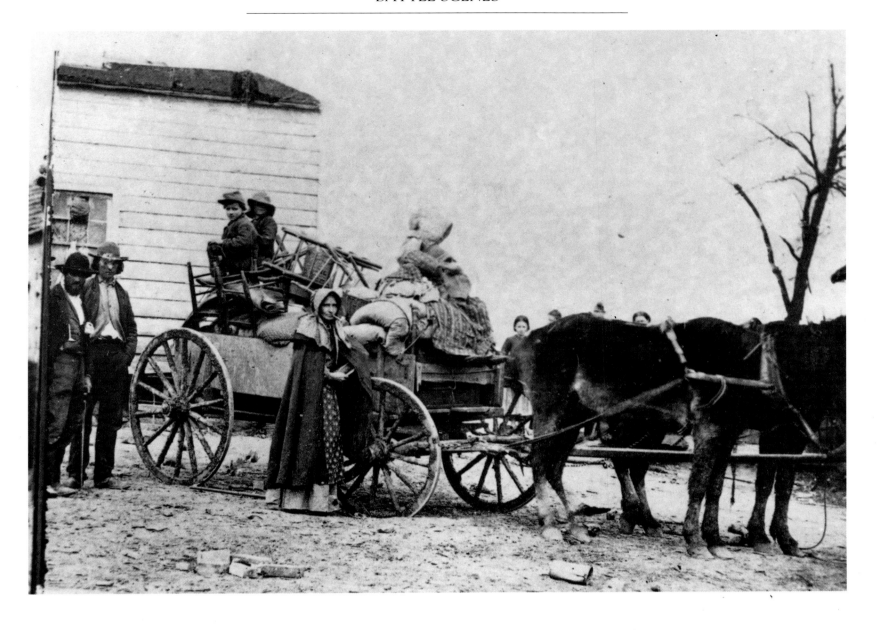

A Southern refugee family
evacuates a war area with
belongings in a cart, c. 1861.

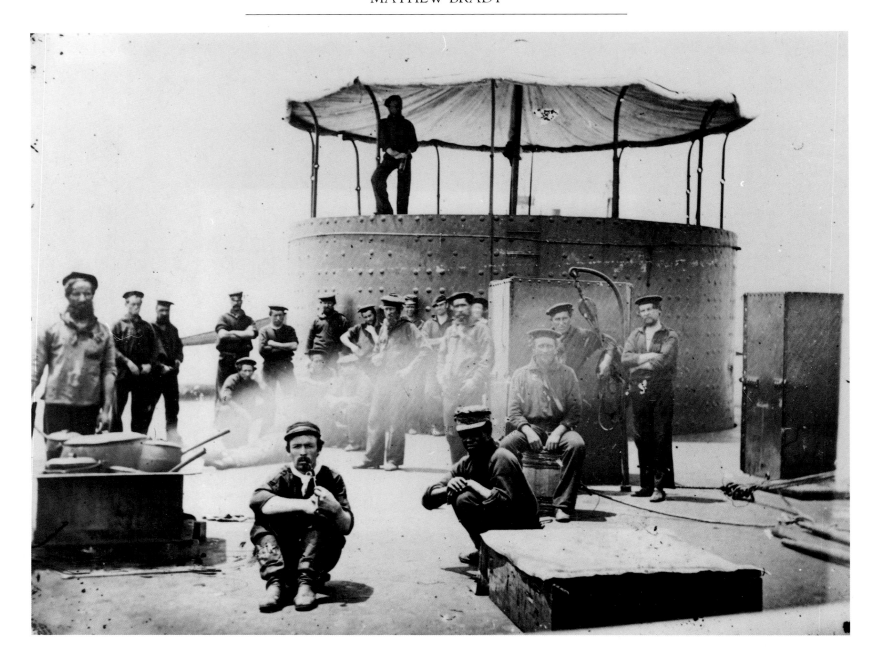

Crew members cooking on the deck of the *USS Monitor* in the James River, Virginia, July 9, 1862.

Right: The Federal Balloon Corps, organized in 1862 by Professor Thaddeus Lowe for purposes of enemy observation, is seen here at Gaines Mill inflating the balloon "Intrepid" from a hydrogen generator, c. 1862.

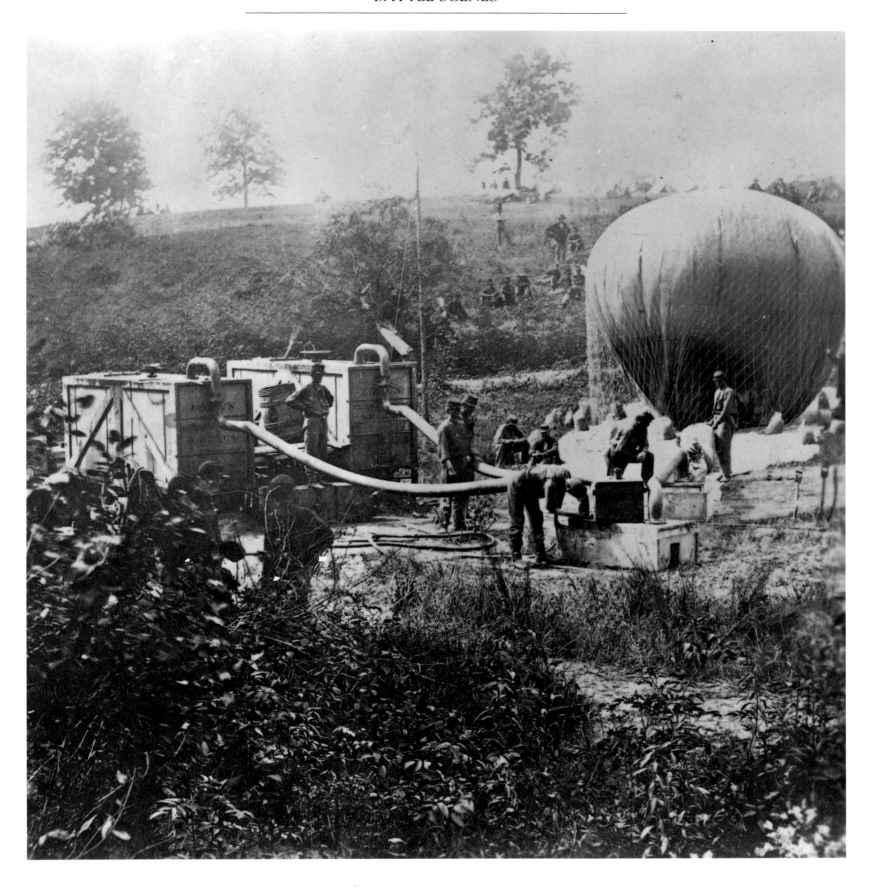

Overleaf: Battlefield of Antietam, Maryland, on September 17, 1862. Shot from McClellan's headquarters at Pry Mansion, this photo is believed to be the only actual battle action picture of the war. Union horse artillery on left, infantry on right. (*Gardner-O'Sullivan/Brady Collection*).

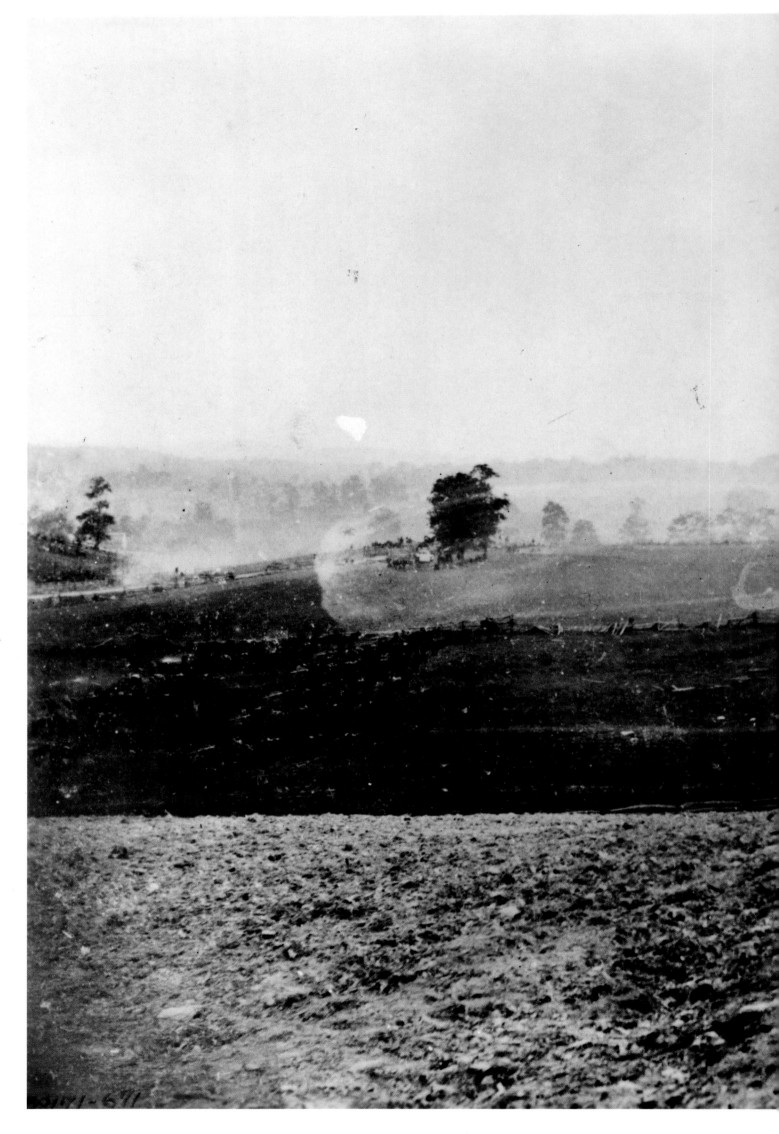

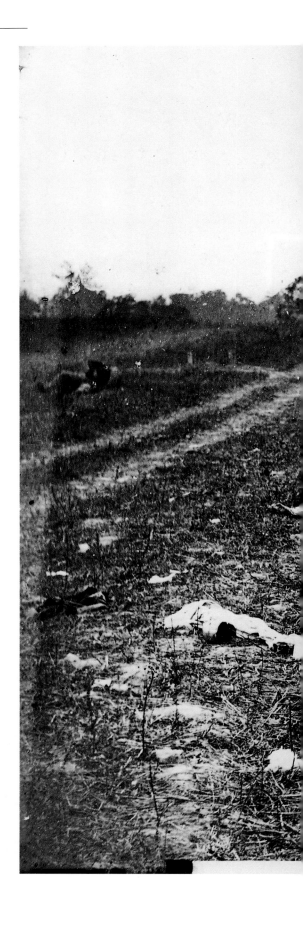

"The Bloodiest Day of the War." Confederate dead sprawled along Hagerstown Pike, Battle of Antietam, September 17, 1862.

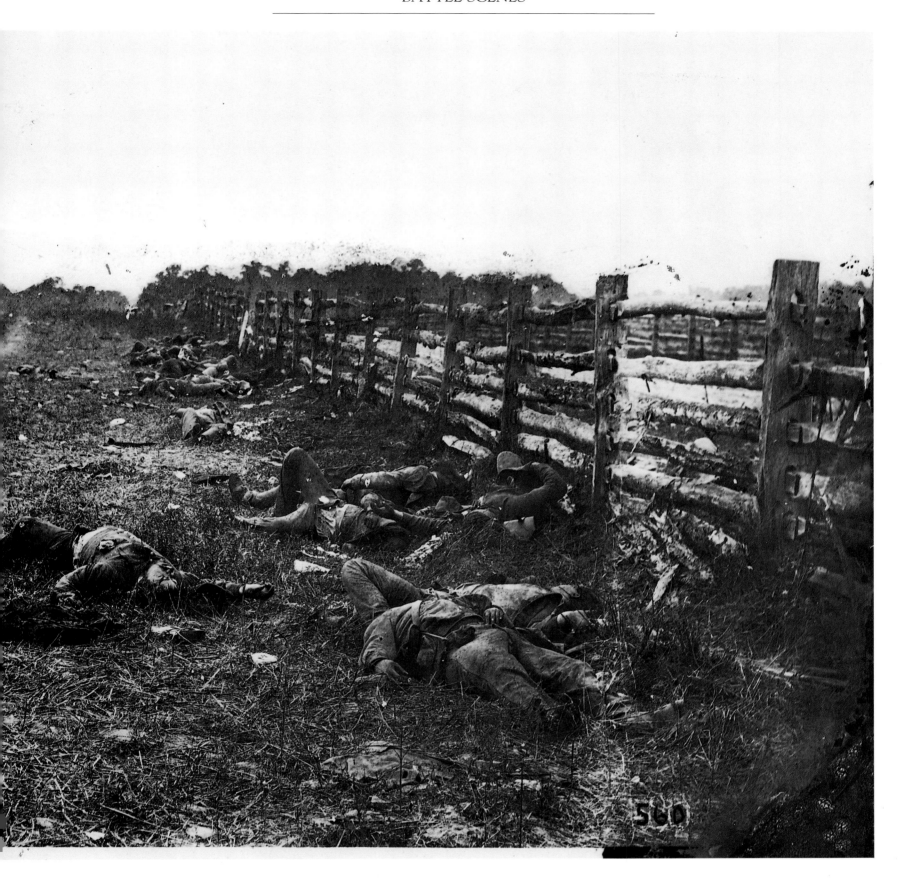

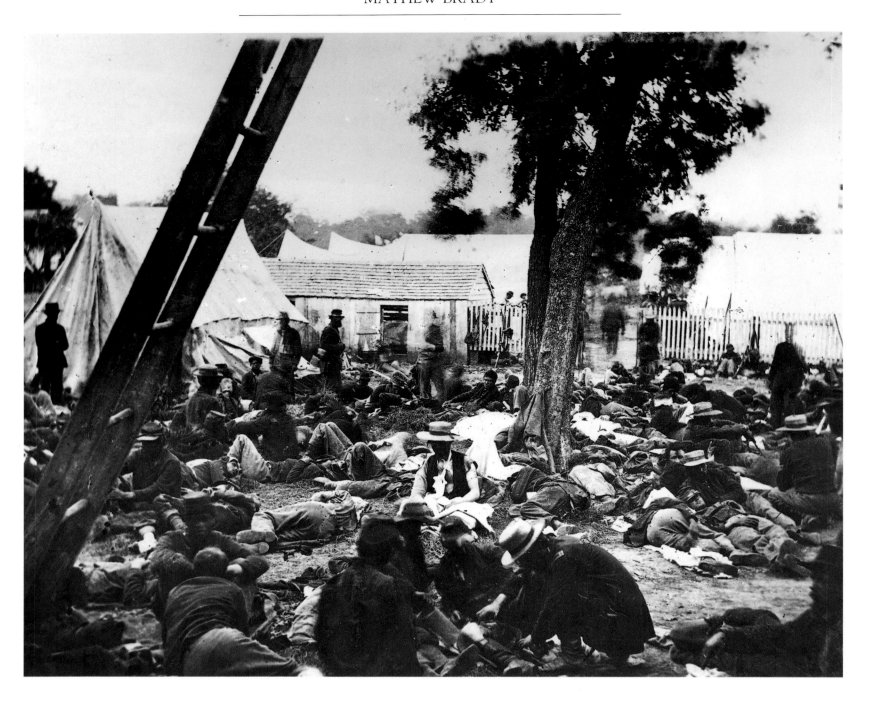

Wounded Union soldiers at
Gaines Mill, Savage's Station
after the Battle of Fair Oaks,
Virginia, 1862. (*James Gibson/
Brady Collection*)

Right: The 1st Connecticut
Artillery, Federal Battery #1,
McClellan's fortifications in
front of Yorktown, Virginia,
during the Peninsular
Campaign, May 1862.

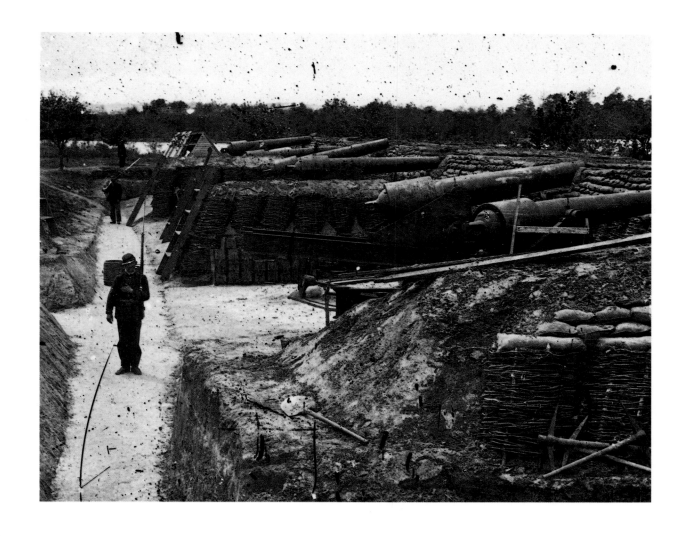

Overleaf: Confederate dead at
Marye's Heights,
Fredericksburg, Virginia,
photographed less than twenty
minutes after being stormed by
Sedgwick's 6th Maine Infantry,
May 3, 1863. (*A.J. Russell/
Brady Collection*)

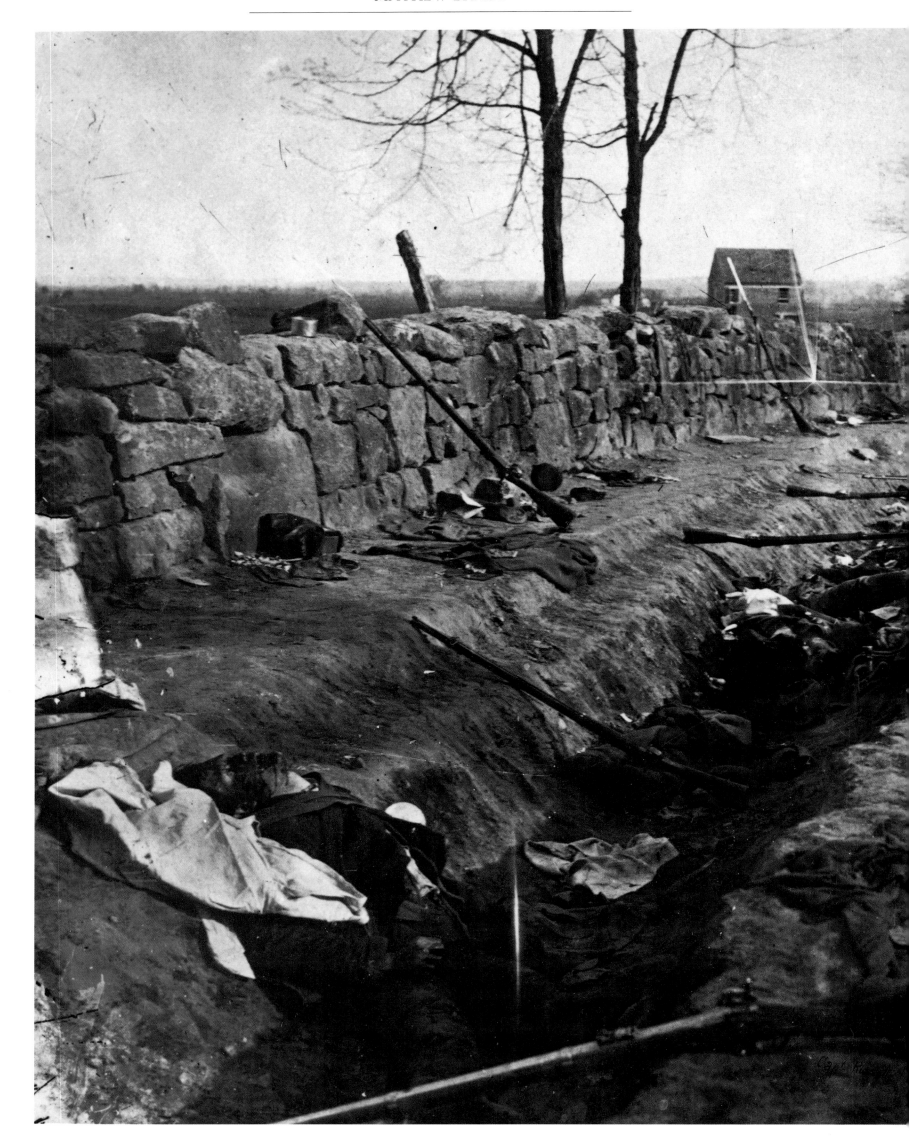

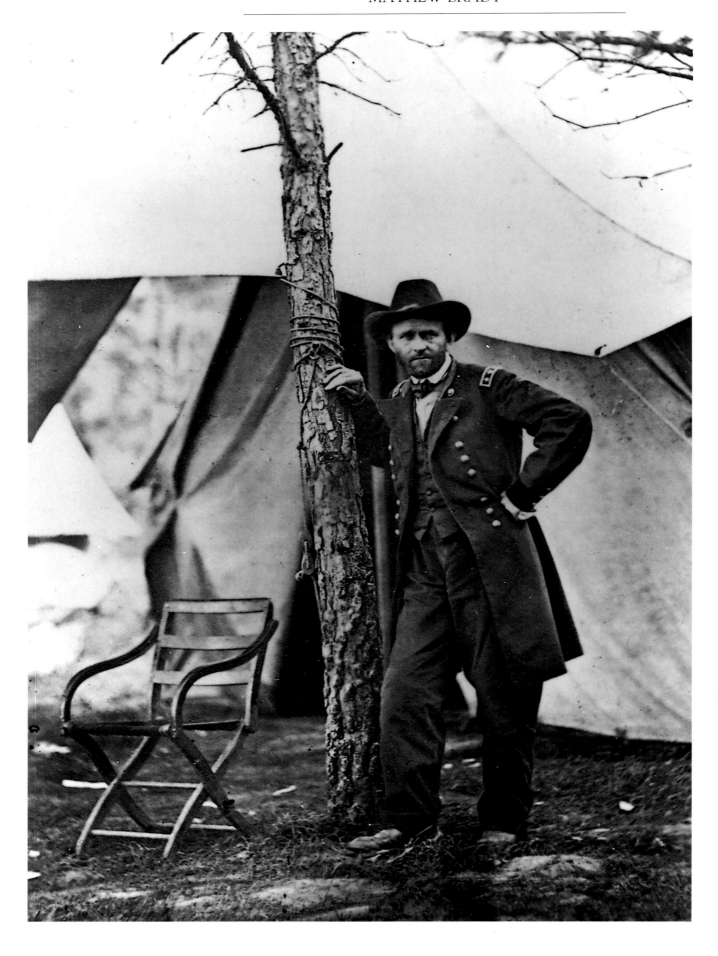

General Ulysses S. Grant
during the Wilderness
Campaign.

Right: Admiral John A.
Dahlgren (1809-1870), U.S.
Navy, "The Father of
American Naval Ordnance," in
front of one of the Dahlgren
guns he designed, c. 1863.

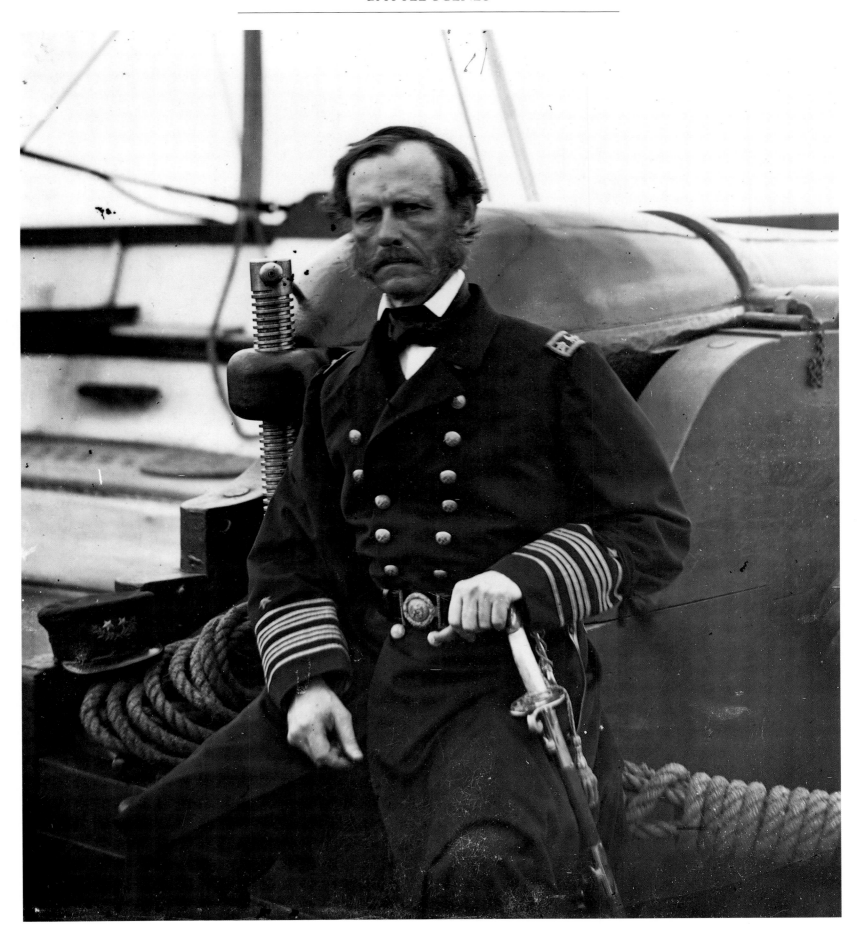

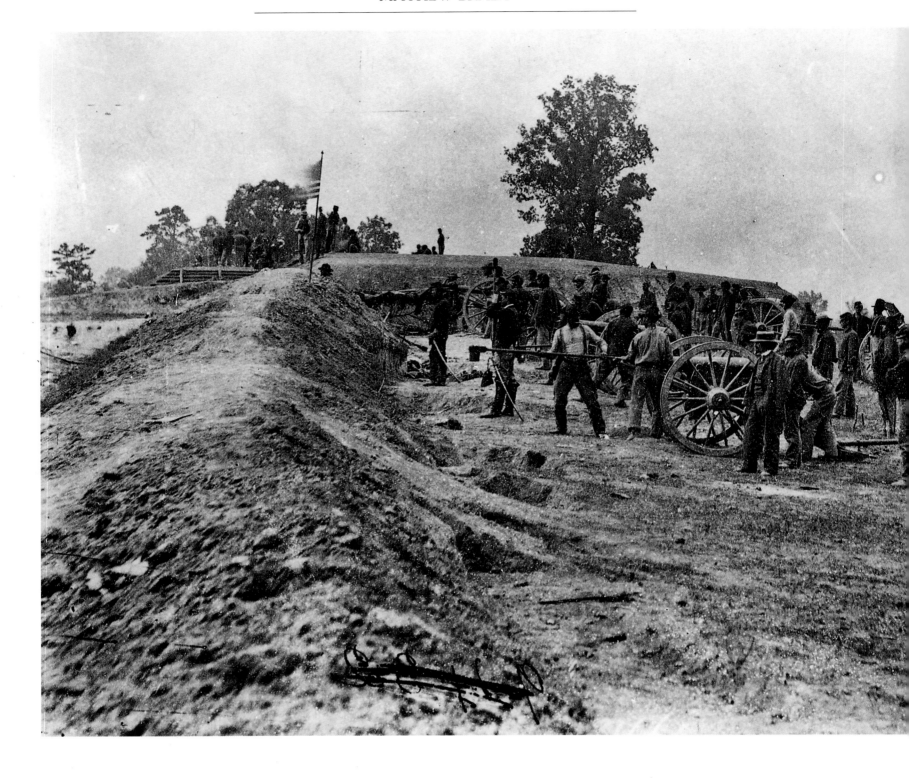

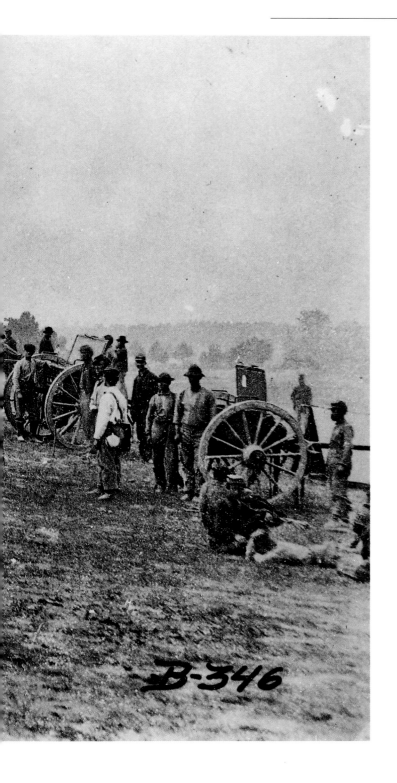

B-346

Mathew Brady, wearing a straw hat, with the 12th New York Battery outside Petersburg, Virginia, June 20, 1864. Two days later the entire battery was captured in a Confederate attack.

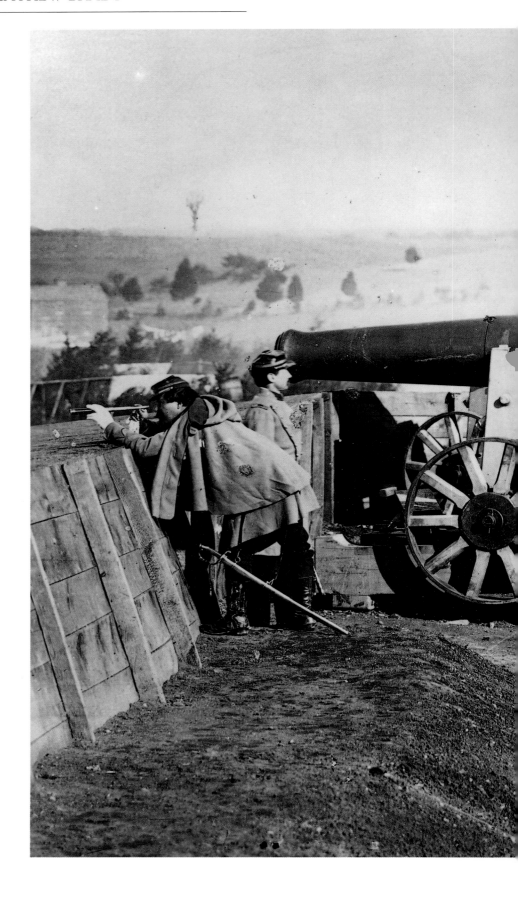

"Dictator," a 13″, 8.5-ton mortar, capable of hurling missiles weighing 200 pounds, is shown mounted on a railroad flatcar during siege operations in front of Petersburg, Virginia, September 1, 1864. (*Timothy O'Sullivan or David Knox/Brady Collection*)

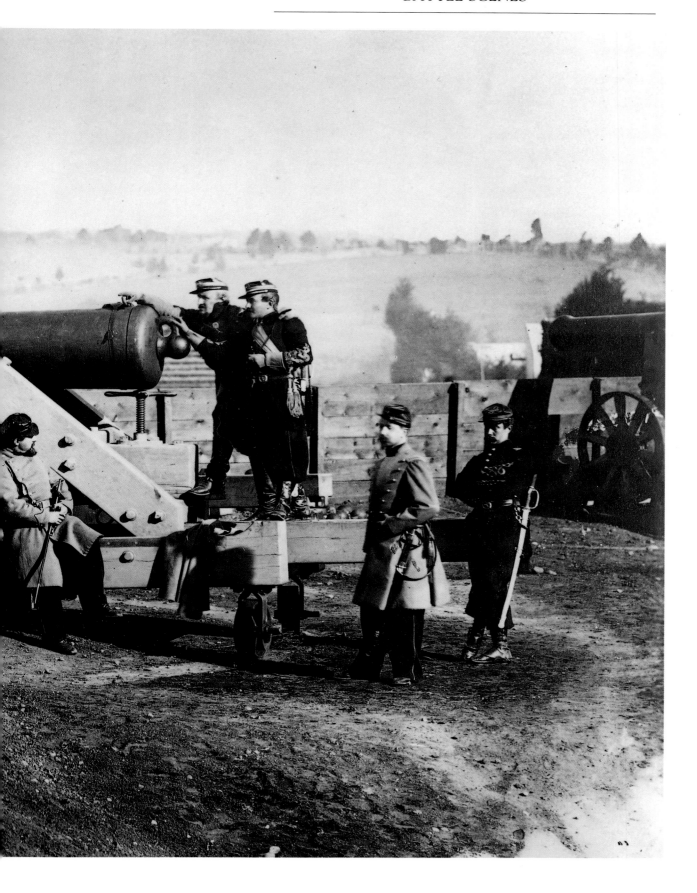

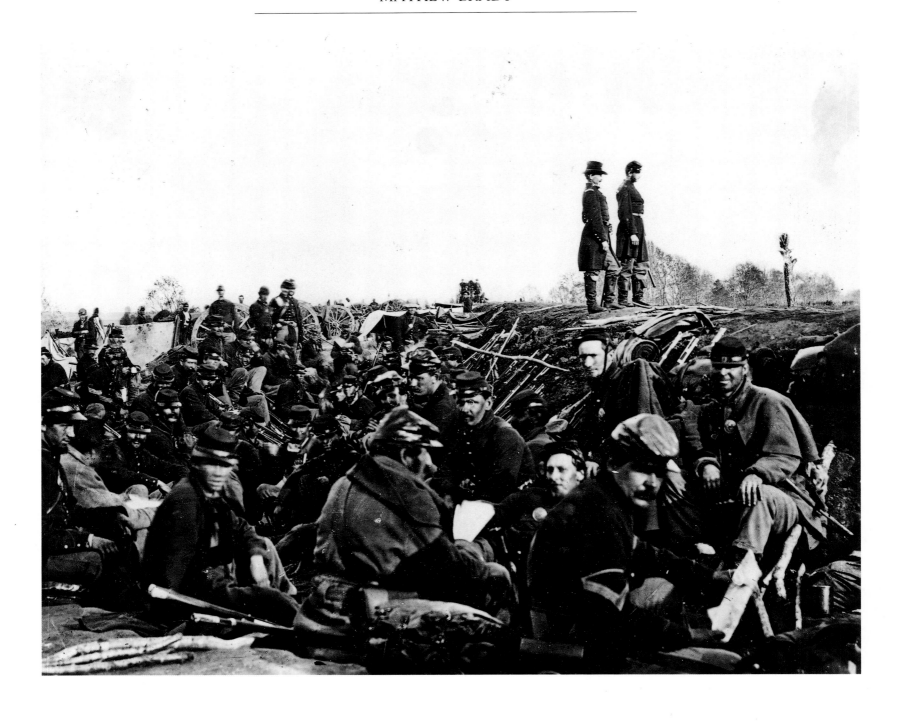

Soldiers of the Army of the
Potomac in the trenches before
Petersburg, Virginia, probably
in the fall, 1864.

Right: Central Signal Station,
Washington, D.C., April 1865.

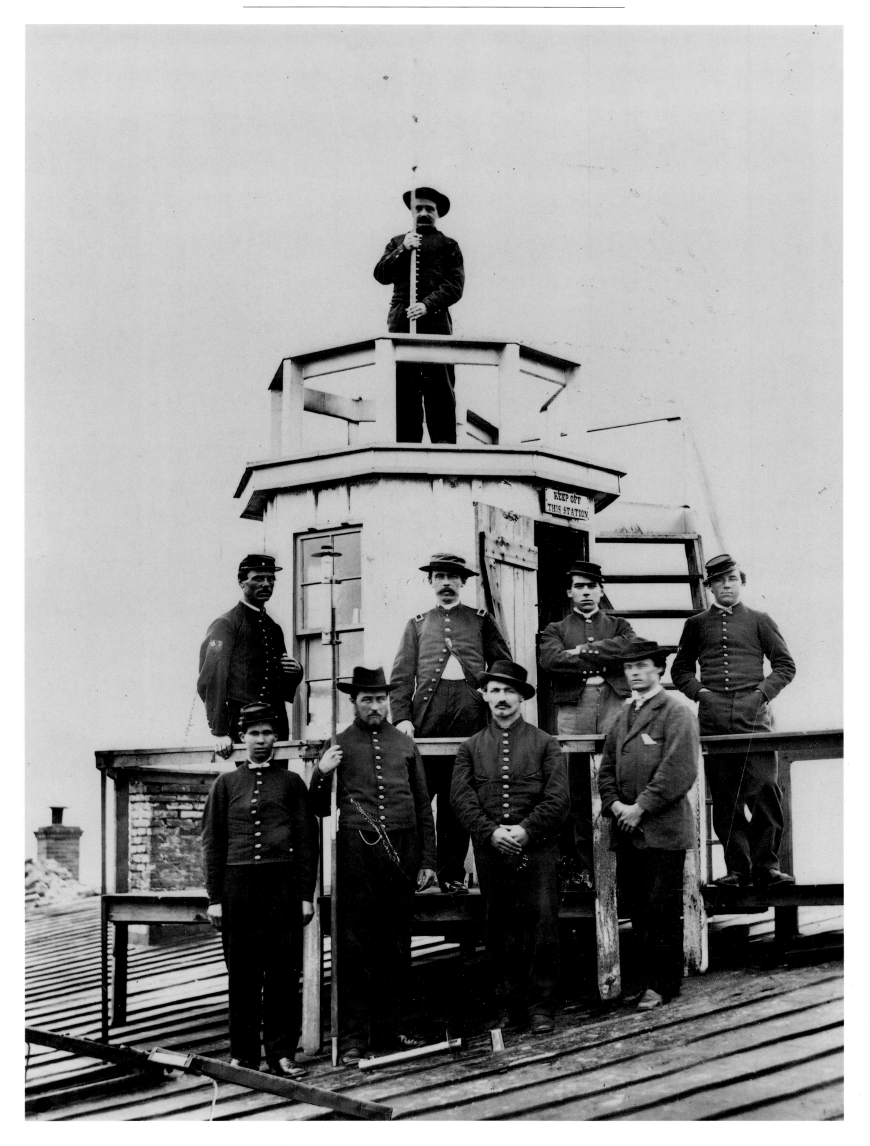

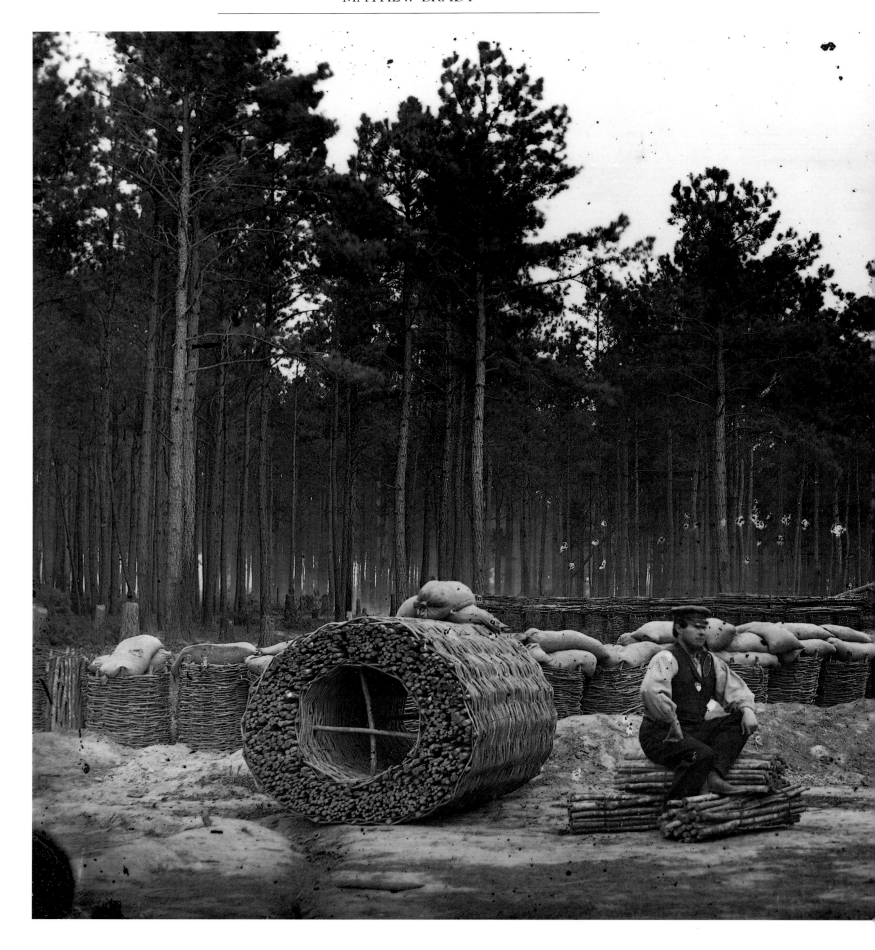

Tons of twigs and branches were woven into gabions, the basketlike defenses filled with earth that protected the line of investment at Petersburg, Virginia, 1865.

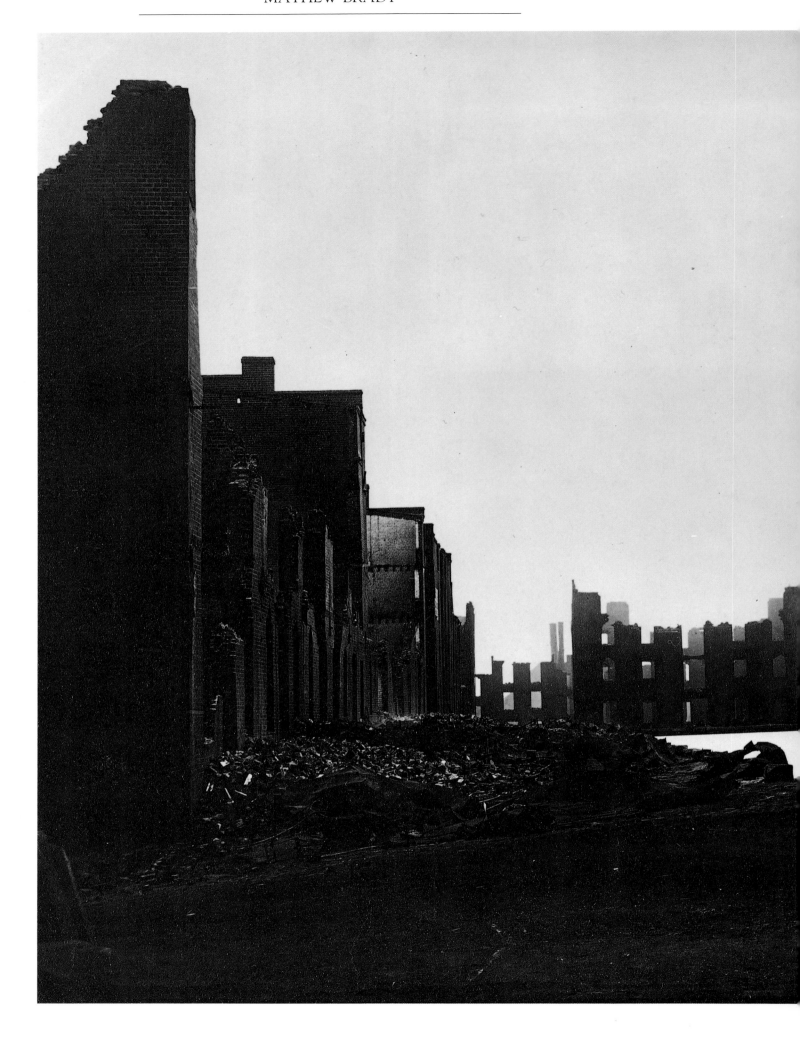

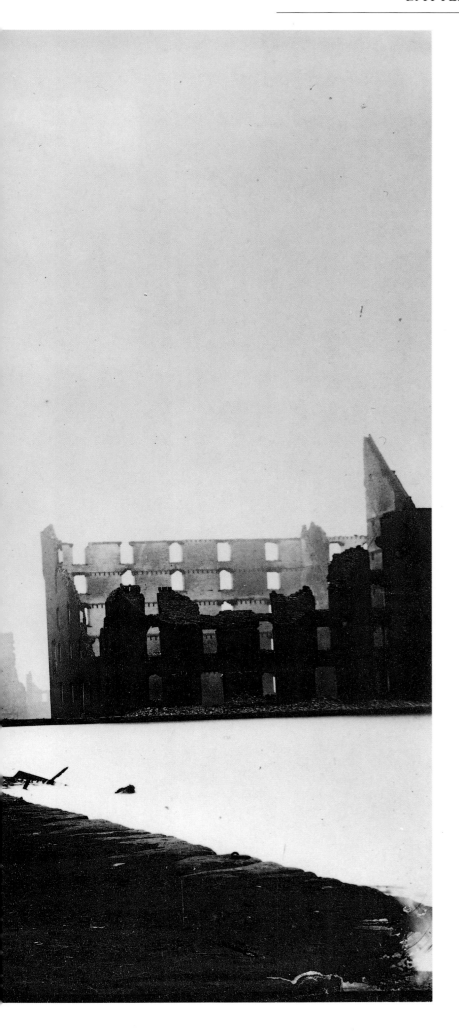

The desolation of war
evidenced at the ruins of
Galligo Mills, Richmond,
Virginia, April 1865.

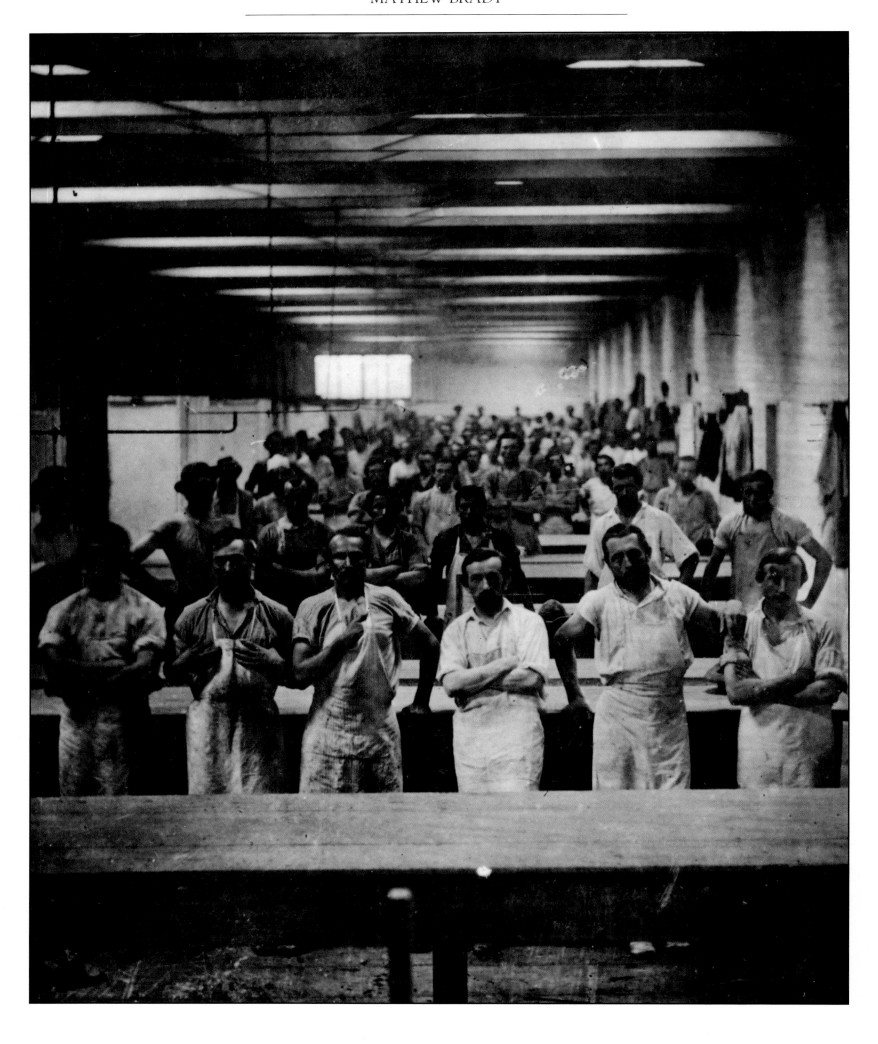

CAMP SCENES

Camp life is as integral a part of war as is fighting. For many reasons, Civil War photographers preferred covering the camps soldiers called home for months at a time to documenting battles. For one thing, some war correspondents lived in comparative luxury. This was particularly true of Brady because of his prominence and friendship with so many generals. Making photographs in the field was so much easier when one had sufficient time, not only to prepare the plates, compose the scene, set the tripod, take the picture and develop the image, but also for rest, conversation and cigars before and afterward.

Another reason is that soldiers spent most of their time in camp. They may have been bored by the repetitive chores there but they were also more cheerful, on the whole, than when under fire or slogging through swamps to get to a battlefield. Camp scenes tended to capture the more regular, everyday qualities of soldiers' lives better than did fighting scenes, and for this reason they were very popular and very dear to the folks back home.

On the other hand, camp life for the war photographer often resembled boot camp more than summer camp. Preparing and developing plates in a cramped darkroom tent meant sweating in the summer, freezing in the winter, and bearing up under back-breaking conditions any time. Bedtime for the soldiers served as a signal for the photographer to light his lanterns, wash, dry and varnish his plates and prepare his chemicals and equipment for the next day.

Camps varied in their levels of comfort, of course. Some were quite snug. Those soldiers not too far from home occasionally enjoyed family visits. News vendors followed the Northern army camps with their carts. (Some newspapers carried such thorough information on the war that Southern strategists occasionally preferred them to their own intelligence.) Contrary to the situation in the Confederacy, Union camps usually enjoyed plenty of food, brought in behind the lines by railroad from the West.

By mutual consent, soldiers fought few battles in the winter and early spring, mainly because roads through Virginia tended to be impassable. However, despite the wishes of many soldiers, the war did not come to an end during these seasons. They did fight some battles – Fredericksburg, for instance. Cavalry units regularly patrolled much of the theatre of war. Life in camp went on, though colder and much more slowly. Brady's photographers worked through the year, but, as they usually operated within a day's travel time from Washington regardless of the season, probably passed a more pleasant winter than did most soldiers.

Mathew Brady had ceased to take his own pictures well before the start of the Civil War. However, while he cannot be credited, or blamed, for some technical aspects of "his" war photographs, he excelled at persuading people to pose in a certain way, to come together for a particular shot and to hold still for the necessary exposure times. Even the horses had to be still! Virtually all photos which appear to be the most spontaneous scenes imaginable are, in actuality, highly orchestrated shots. Spontaneity, like motion, would have to wait until later in the century.

It was in their camp scenes that photographers caught many of the daily events of the Civil War. There was laundry to be done, cattle to be slaughtered and prepared for the table, wood to be chopped and food to be cooked. Tents or semi-permanent structures were erected, weapons were stored and kept clean and horses were cared for. Blacksmiths and other craftsmen set up shop and carried on their work almost as though they were at home. Soldiers stationed on gunboats had special tasks and chores, of course. In their spare time, soldiers might play cards or ball, run races, and, if they were literate, catch up on news from home or write a letter.

In some of the more permanent camps, especially those closer to home, the army permitted entrepreneurs to sell their wares. Newspapers, as mentioned, were often available. Restaurants, patronized primarily by officers, provided some degree of relief from army rations. Sutlers, or army provisioners, often sold merchandise from a store in camp. Even embalmers set up shop and offered their special services to those who could afford to have their loved ones preserved for burial in their native soil.

Left: Cooks of a large camp
mess hall, n.d.

Brady's "What-is-it" wagon. The photographers are believed to be David Woodbury (l) and E. Guy Foux (r), in front of Petersburg, Virginia, 1864.

Overleaf: Encampment of the Army of the Potomac at Cumberland Landing on Pamunkey River, May, 1862. (*James Gibson/Brady Collection*)

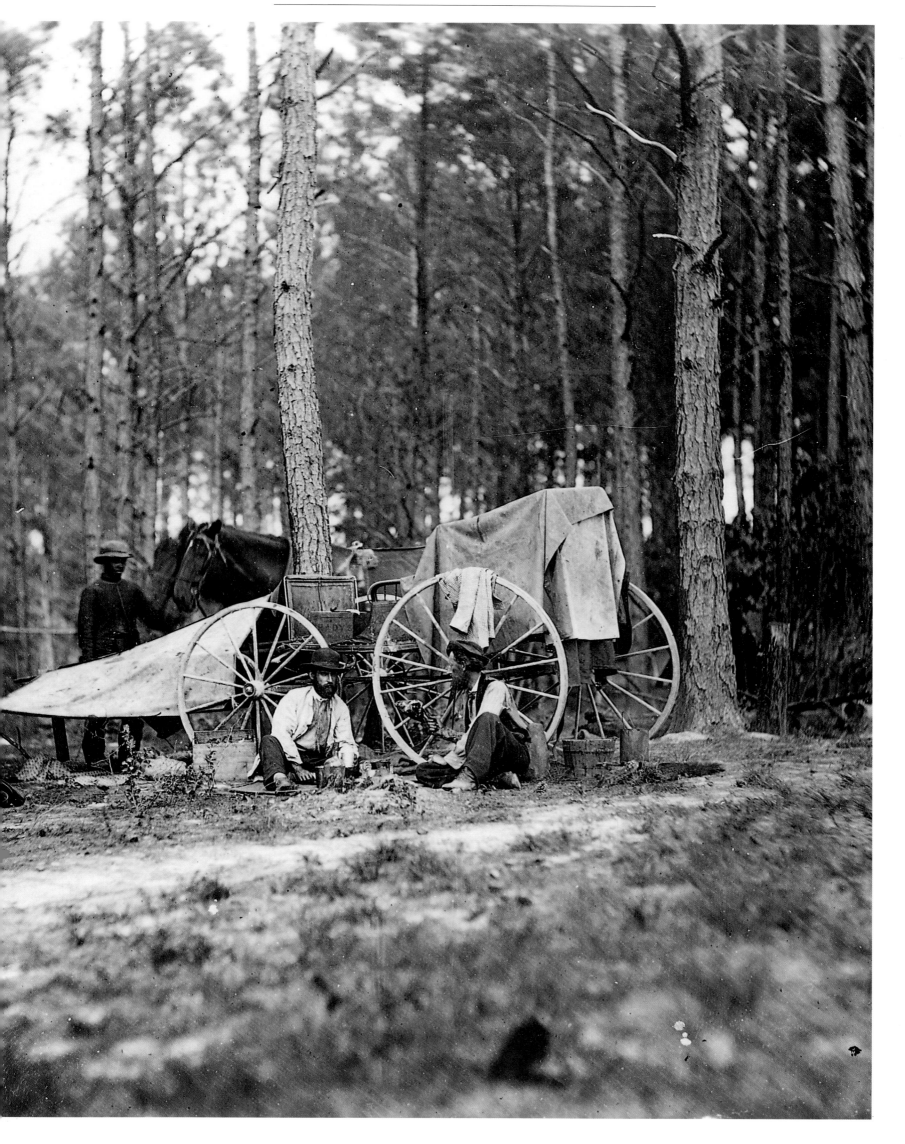

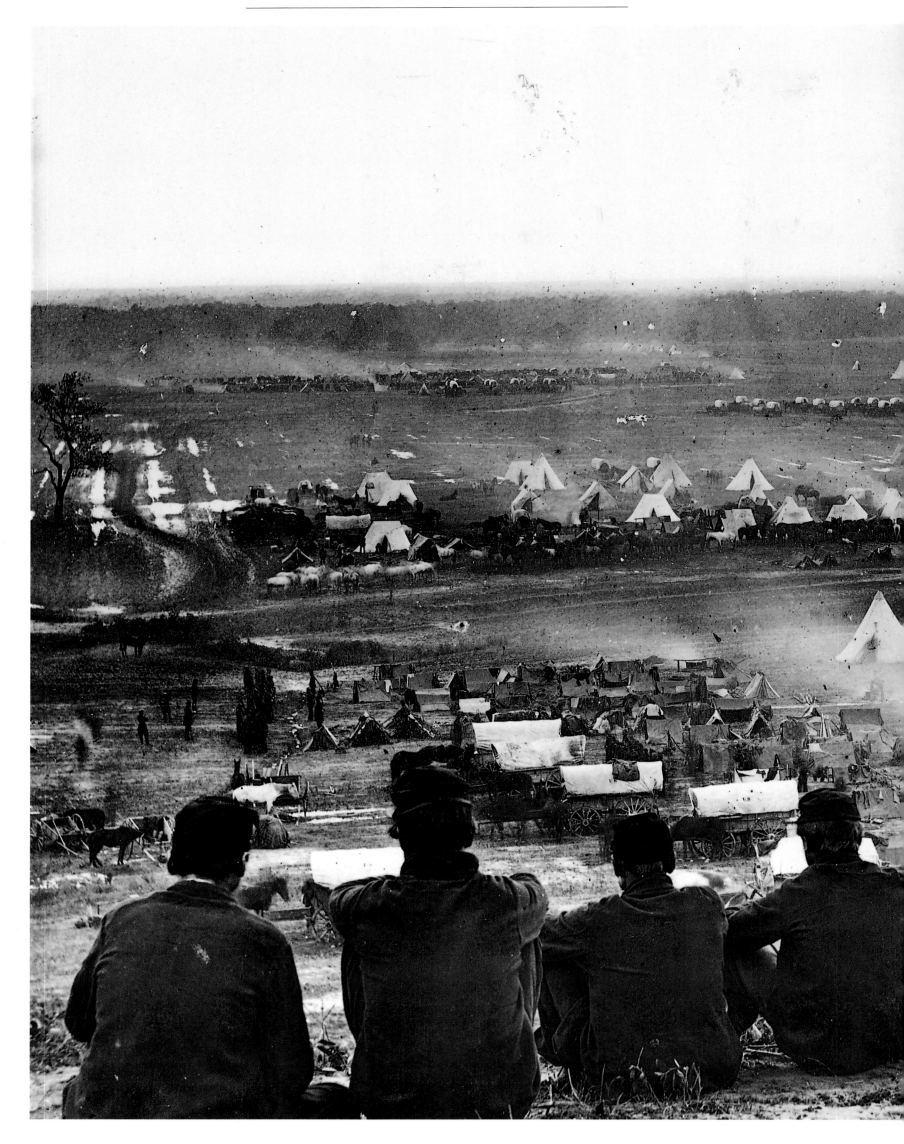

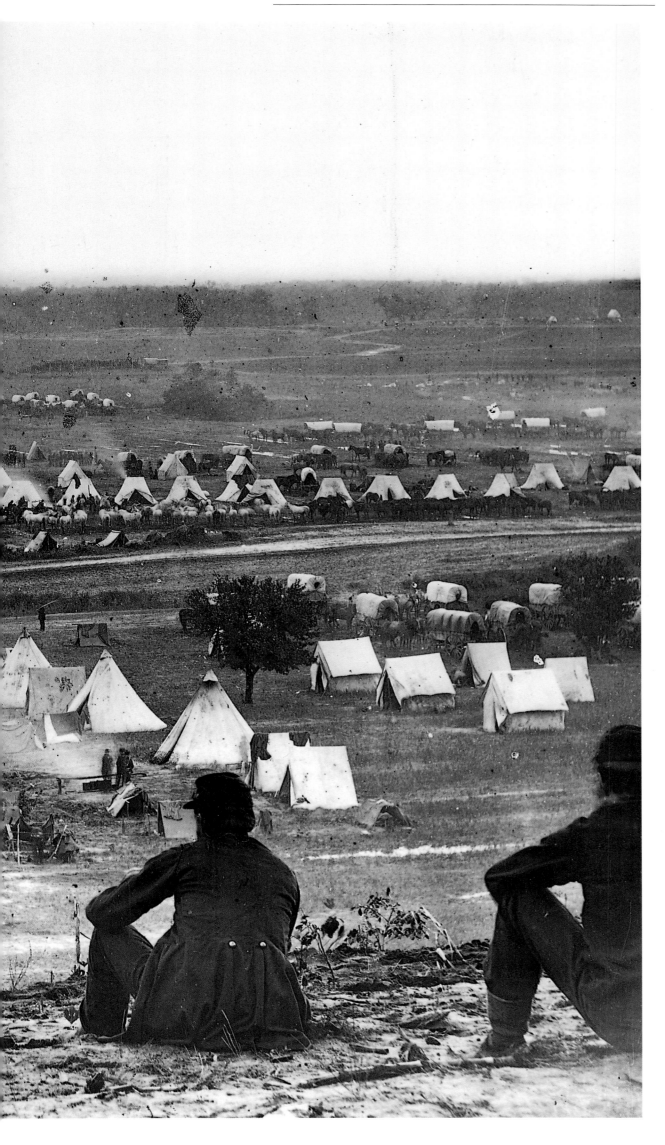

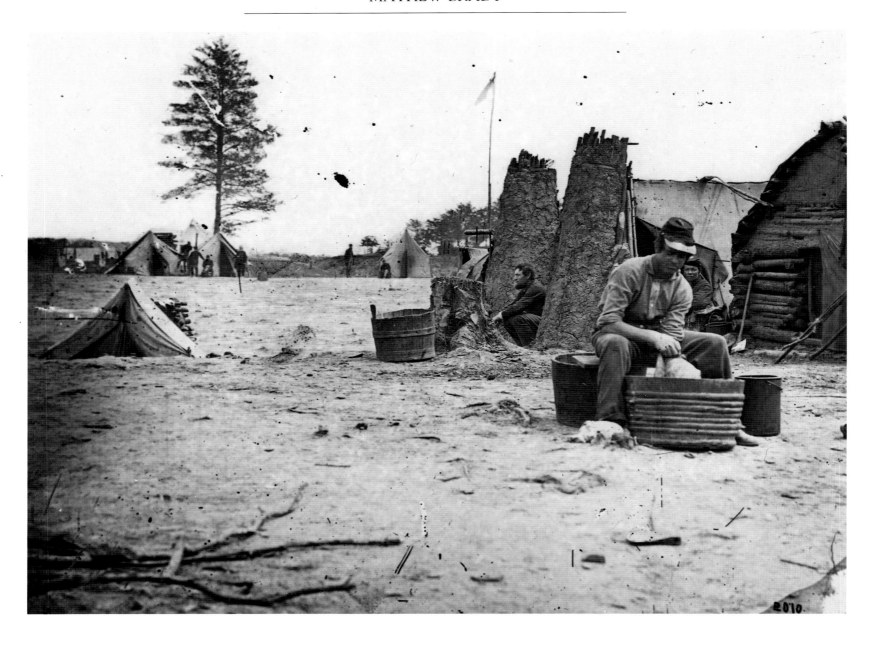

In the camp a soldier's tasks
included slaughtering cattle,
chopping wood, and doing
laundry.

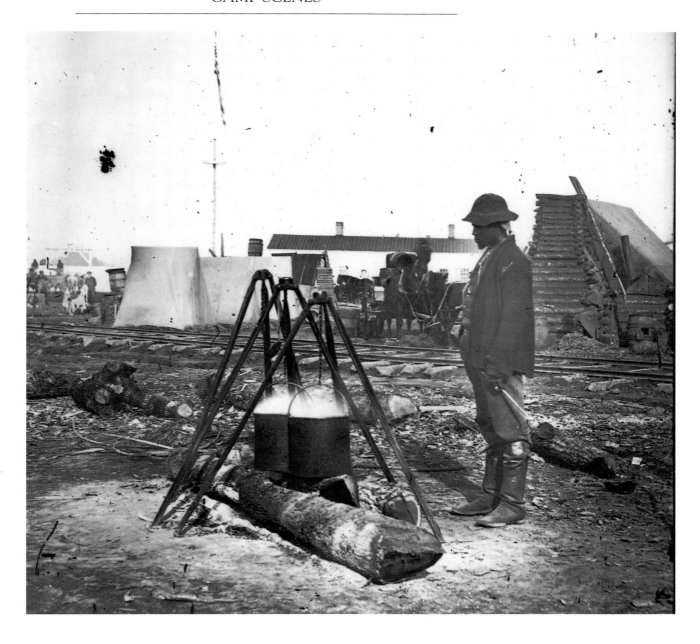

Until 1863, black Americans
were not allowed to bear arms,
but could be found in both
armies tending to noncombat
duties, as illustrated by this
man cooking beans at West
Point, Virginia, n.d.

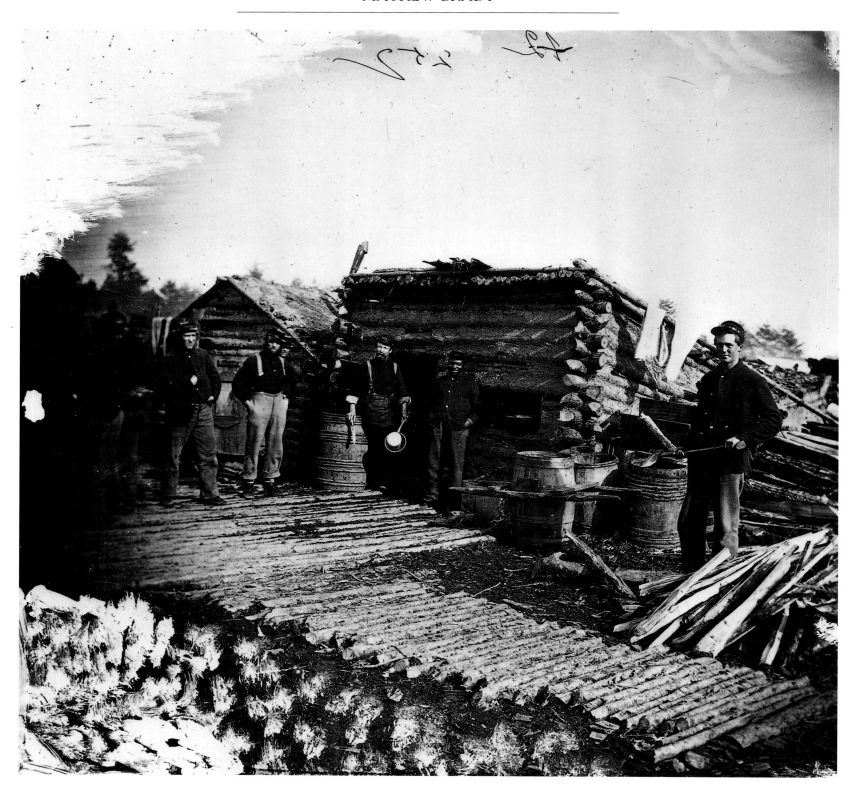

A corduroy road at the camp
company kitchen of the 6th
New York Artillery at
Brandy Station, Virginia, April
1864.

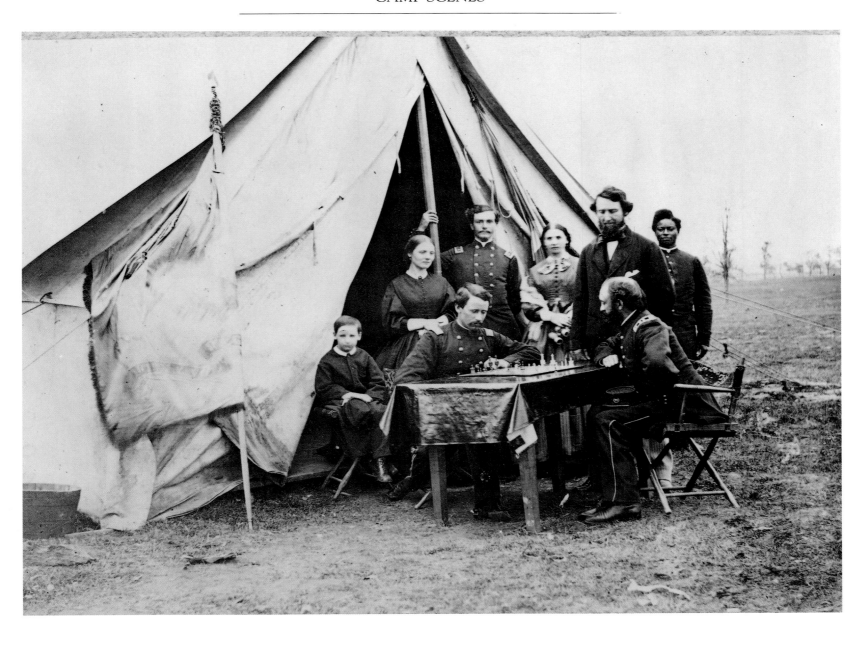

Soldiers at the Headquarters of
the 164th New York Infantry
with their visiting families relax
with a game of chess.

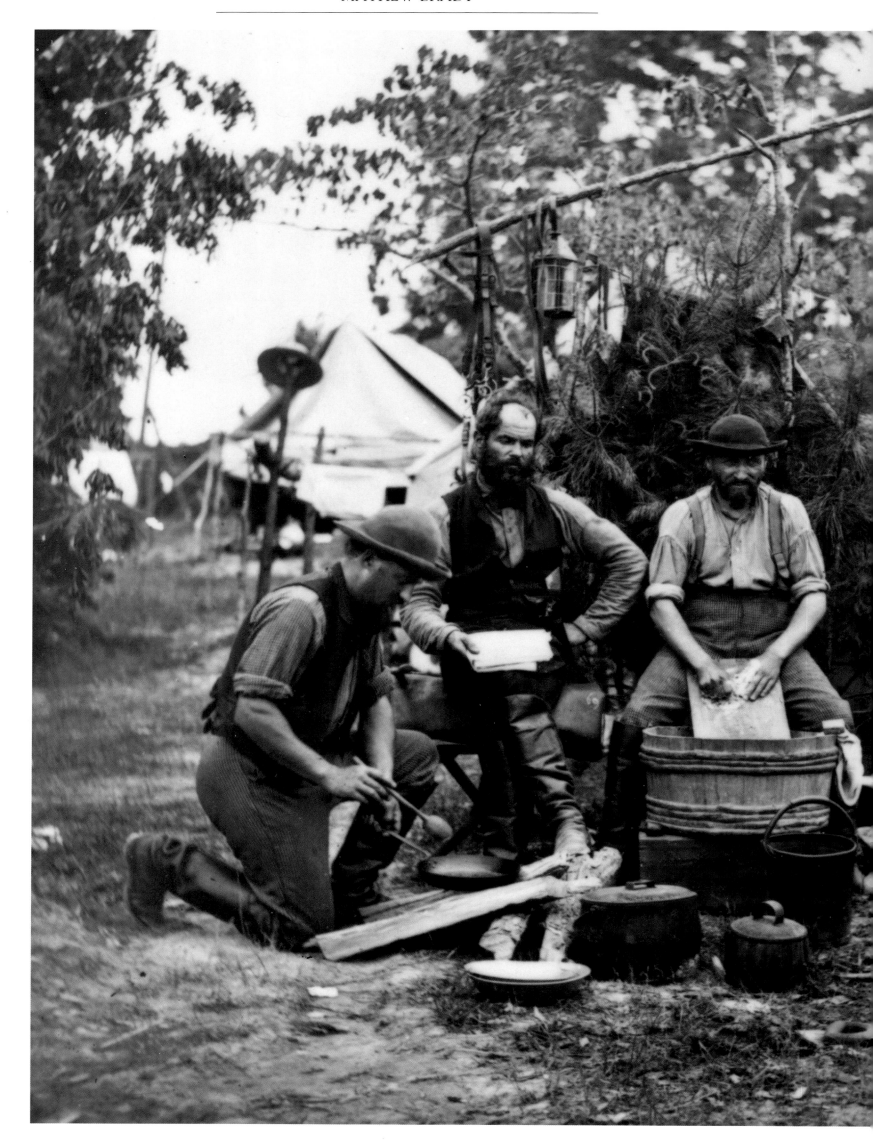

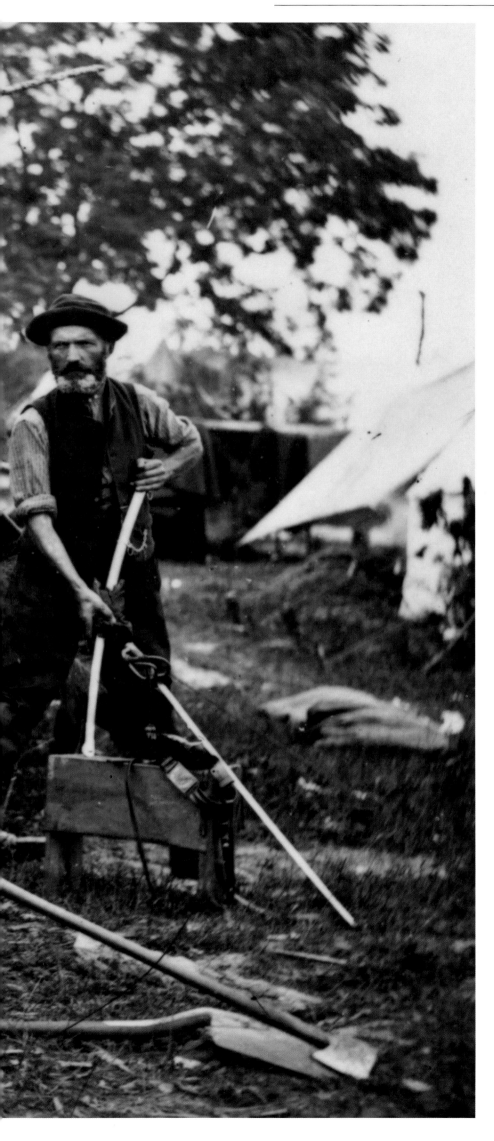

Servants of Prince de Joinville doing chores at Camp Winfield Scott, in front of Yorktown, Virginia, May 3, 1862. (*James Gibson/Brady Collection*)

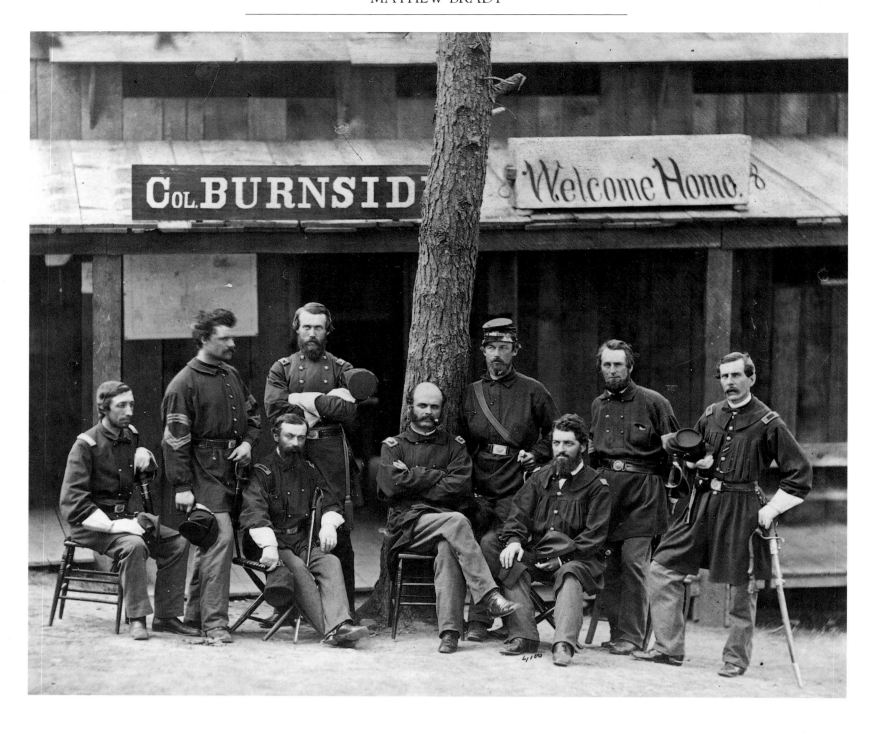

Colonel (later General) Ambrose
Burnside and officers of the 1st
Rhode Island Volunteers,
Camp Sprague, 1861.

Right: Captain Edward A.
Flint's horse, headquarters,
Petersburg, Virginia, 1864.

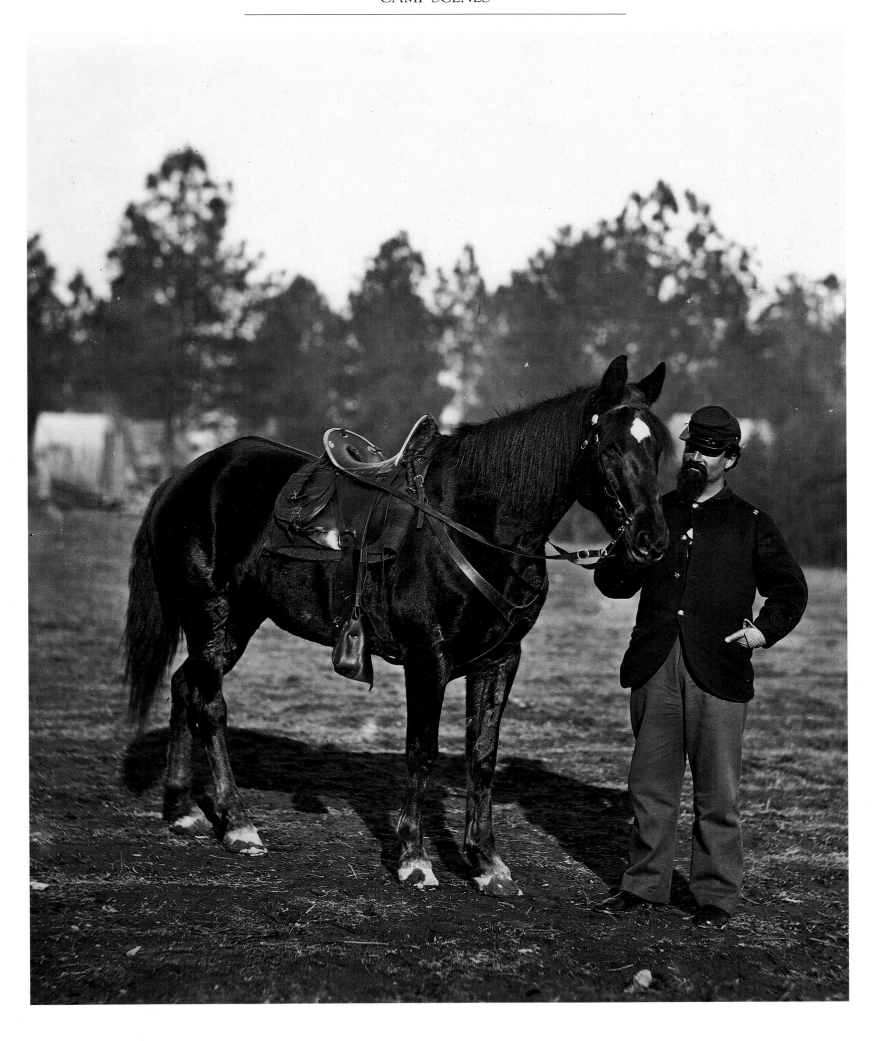

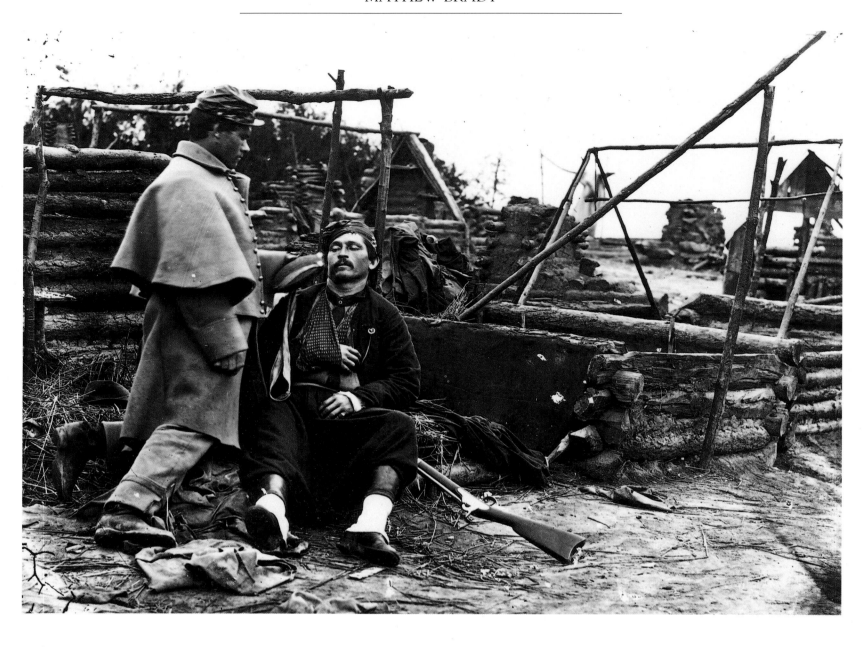

Deserted camp and wounded
soldier in a Zouave uniform, c.
1865.

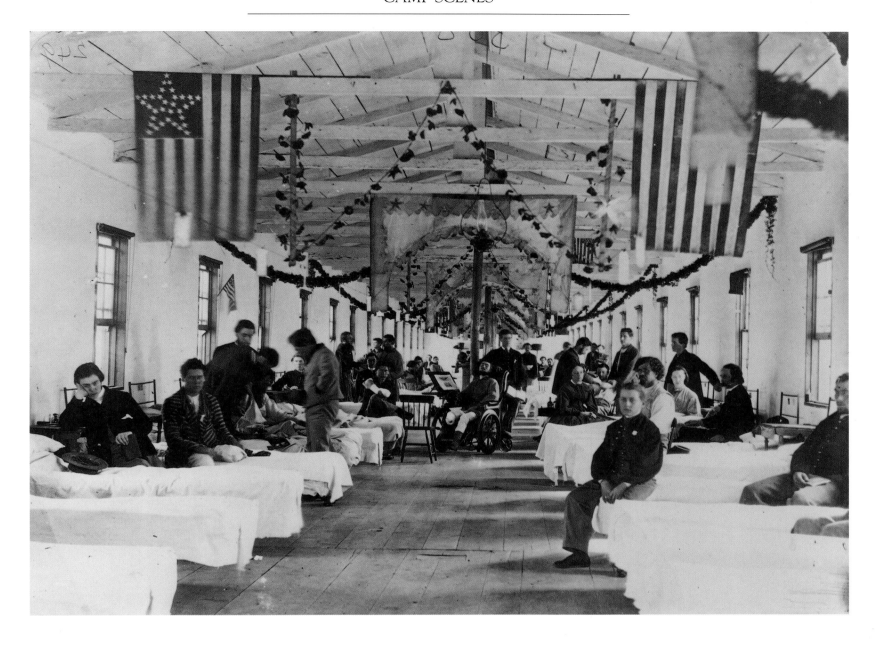

Armory Square Hospital for
Union Army veterans in
Washington, D.C., decorated
either for the 4th of July or
perhaps the end of the war,
n.d.

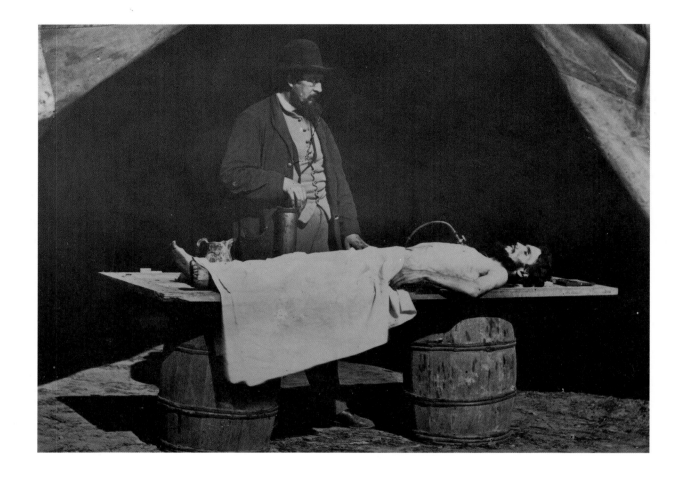

Itinerant embalmers followed
armies and advertised their
services to those who wished to
have their dead brought home
for permanent burial.

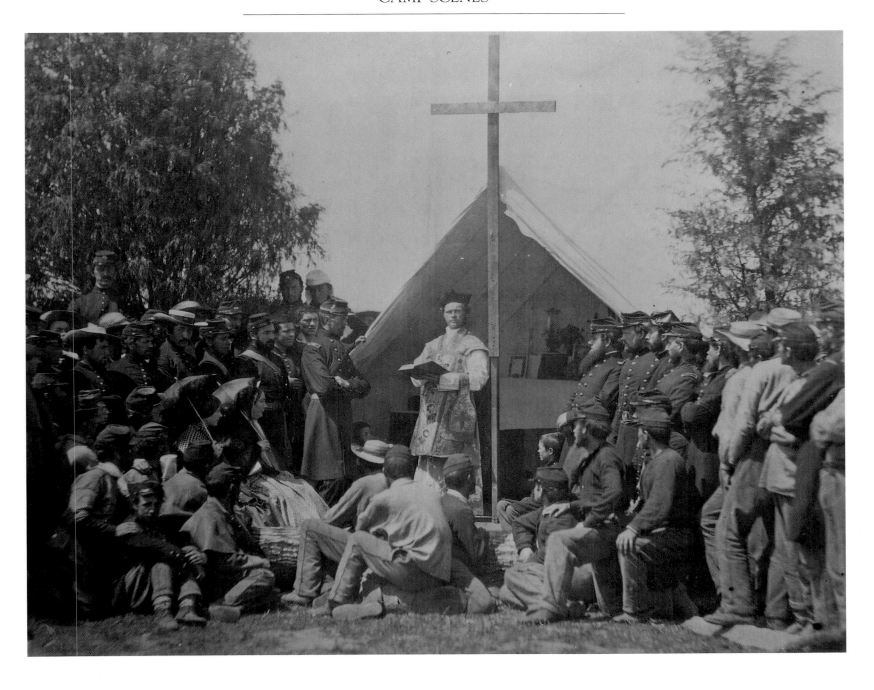

Father Thomas H. Mooney
performs Sunday Mass for the
69th New York Infantry
Regiment with members of
their families.

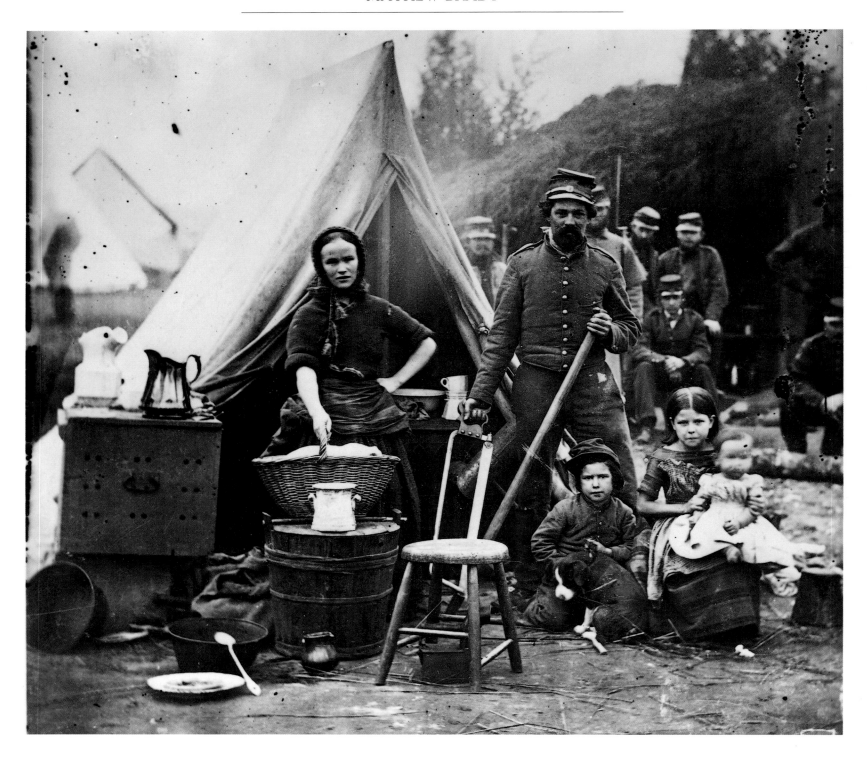

The camp of the 31st
Pennsylvania Infantry near Fort
Slocum, near Washington,
D.C., 1862.

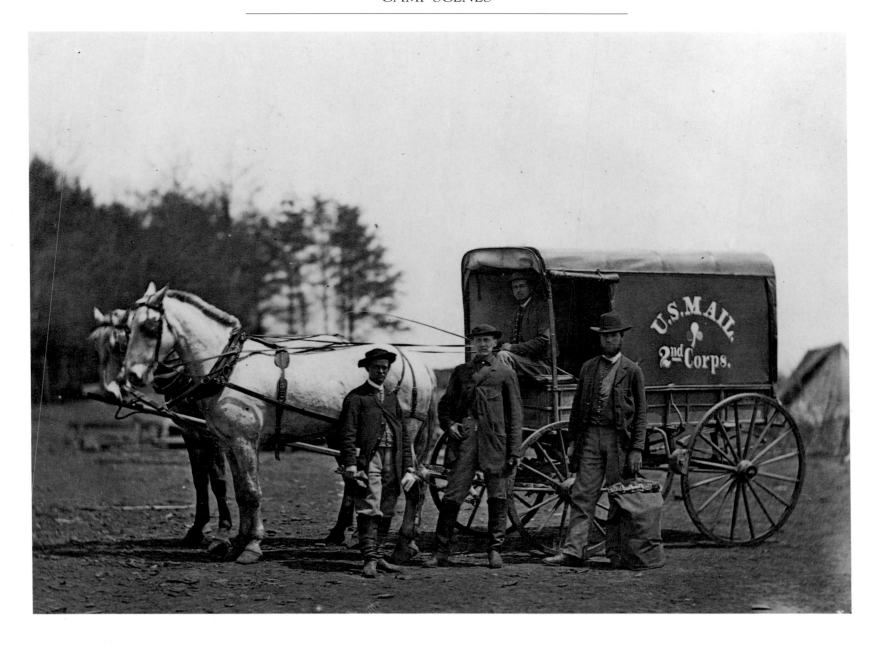

The Mail Wagon of the 2nd
Army Corps, Brandy Station,
Virginia, April, 1864.

LIST OF PHOTOGRAPHS

Photo Credits
Bayerisches Nationalmuseum: 8
The Bettmann Archive: 7 (bottom), 9 (left), 10, 11 (top left and bottom), 12, 13, 22, 24, 26, 27, 28, 30, 35, 42-43, 44-45, 47, 48-49, 53, 56, 57, 58-59, 60, 64-65, 68, 82-83, 108.
Courtesy of the Buffalo Bill Historical Society, Cody, WY: 61
Chicago Historical Society: 78-79
Library of Congress: 7 (top), 9 (right), 11 (top right), 16, 17, 18, 21, 23, 29, 31, 32, 38, 39, 40, 46, 50, 51, 52, 54-55, 70, 71, 72, 73, 74, 75, 76, 77, 80, 84-85, 86, 94-95, 96-97, 99, 100, 101, 102-103, 104, 105, 106, 108, 110, 111
Lincoln Library and Museum, Ft. Wayne, IN: 21
Museum of Modern Art, New York, NY: 90-91
Museum of Confederacy: 87, 107, 109
National Archives: 13 (right), 14, 15, 25, 33, 34, 36, 37, 62, 66-67, 69, 81, 88-89, 92, 98.
New York Historical Society/The Bettmann Archive: 6

Acknowledgments
The author and publisher would like to thank the following people who helped in the preparation of this book: Design 23; Susan Bernstein, the editor; and Kathy Schneider, the picture editor.